HOW TO GET STARTED SELLING YOUR ART

HOW TO GET STARTED
SELLING YOUR ART

CAROLE KATCHEN

NORTH LIGHT BOOKS

CINCINNATI, OHIO

ABOUT THE AUTHOR

Carole Katchen has been a successful professional artist for over thirty years. Her art has been exhibited in galleries throughout the United States and published in books around the world. She is also well-known for the articles and books she has written about art. One million copies of her books have been sold. She is a contributing editor to *The Artist's Magazine* and has been published in *American Artist, Southwest Art, Parents'* and *Cosmopolitan*. This is her fifteenth published book. Her most recent are *Painting With Passion* and *Make Your Watercolors Look Professional*. She lives in Hot Springs, Arkansas, and teaches workshops around the country.

How to Get Started Selling Your Art. Copyright © 1996 by Carole Katchen. Printed and bound in the United States of America. All rights reserved. No part of this book may be reproduced in any form or by any electronic or mechanical means including information storage and retrieval systems without permission in writing from the publisher, except by a reviewer, who may quote brief passages in a review. Published by North Light Books, an imprint of F&W Publications, Inc., 1507 Dana Avenue, Cincinnati, Ohio 45207. (800) 289-0963. First edition.

Other fine North Light Books are available from your local bookstore, art supply store or direct from the publisher.

The print marketing checklist on page 119 is used with permission of Sue Viders, Art Marketing Director for Color Q, Inc.

00 99 98 97 96 5 4 3 2 1

Library of Congress Cataloging-in-Publication Data

Katchen, Carole.
 How to get started selling your art / Carole Katchen.—1st ed.
 p. cm.
 Includes index.
 ISBN 0-89134-685-6 (alk. paper)
 1. Art—Marketing. I. Title.
N8600.K36 1996
706'.8'8—dc20 96-15064
 CIP

Edited by Joyce Dolan
Cover and interior design by Brian Roeth

North Light Books are available for sales promotions, premiums and fund-raising use. Special editions or book excerpts can also be created to specification. For details, contact Special Sales Manager, F&W Publications, 1507 Dana Avenue, Cincinnati, Ohio 45207.

DEDICATION

This book is dedicated to the artists, dealers and collectors of Hot Springs, Arkansas, a whole town that has the courage to commit itself to art.

ACKNOWLEDGMENTS

Special thanks to Rachel Wolf, Pamela Seyring and Joyce Dolan, the editors of this book, and also to Brian Roeth for the great design.

Table of Contents

You Can Be a Professional Artist

This book is for those people who really want to be artists but think they are too old or too young, have too many family commitments, don't have enough family support or feel they are "not good enough." It is designed to lead you through the sometimes terrifying experience of starting your professional career as an artist.

You Can Be an Artist

Whether you are young or old, man or woman, married or single, rich or poor, brilliant or average—there is a way for you to be a successful professional artist. All you need is the desire to do it.

Over my long career as an artist, and as a writer about artists, the only thing I've found that all successful artists have in common is that they want to be artists. At some point they made a commitment to being an artist and then just kept at it until it became reality.

"Oh, sure," you're thinking, "that's easy for you to say. What about me? I want to be an artist. So why am I still teaching second grade?"

HOW TO PROCEED

Lack of information and not knowing what to do next are two things that can stop you from being an artist. For example, let's say you've been taking drawing and painting classes for the last five years and your closets are stuffed with figure studies and still lifes. Do you know what to do now?

Or you've been a member of your local watercolor society for three years, have hung your florals in every hospital and restaurant in the entire city and have not made a single sale. What do you do now?

Or, you've shown your bronze sculptures in galleries all over your ten-state region, and you still don't make enough money from sales to pay your foundry bills. What now?

This book will teach you how to develop a local collector base for you art, then how to take it to a wider market—in easy stages. We'll go through the process of becoming a professional, someone who looks at making art not just as an enjoyable thing to do, but as a viable way to earn money. I believe in taking a practical, organized approach to your art career, step by step. If you concentrate only on the next step, you can avoid being overwhelmed by the enormity of the art market.

THE SECRET TO YOUR SUCCESS: MANAGE FEAR

Fear stops aspiring artists even more than not knowing how to proceed. Fear of failure is one of the biggest fears we all have to contend with. So many potential artists never even begin because they are afraid they will fail.

The first step in managing fear is accepting it. Only after many years of success and failure did I learn that courage is not being without fear; courage is being afraid and proceeding with your life anyway. Fear is your friend—fear is what constantly makes you do your best.

The next step in managing fear is to identify *what* you fear. Then you can actually use those fears to proceed. Grab a piece of paper right now and write down reasons you are afraid to become an artist (see the exercise at the end of this introduction). Be candid—this is only for you.

One of the most effective techniques I know for handling fear is looking at it from another perspective. Almost any disadvantage can also be viewed as an advantage. Develop the ability to stand back and look at something from a different direction. Many years ago I learned that if I am having trouble solving a problem in a painting, I can look at that painting in a mirror. Seeing it backwards will often make the mistakes obvious. It is the same with looking at your life.

Try to imagine how the fear would appear at a different time. Say you are scared to start being a real artist because you think you are too old. How would you have felt five years ago? I bet you would have felt just the same, even though you were five years younger.

The ironic thing is that you cannot *fail* as an artist. The very act of being an artist, of spending your time creating art, is a success. You might not make a lot of money at first. You might be rejected by some dealers and art show juries. But those are not failures. They are simply setbacks on your path toward greater success.

FIND YOUR SUBJECT

Gil Dellinger, known for his commanding pastels of the Northern California coast, didn't always paint landscapes. He explains how he found the right subject.

"I was driving across the countryside every day taking my kids to school. I looked at the light on the fields and began to notice the grandeur of nature around me, the beautiful skies with huge towering clouds in the winter, the rich colors and textures of the farmland. I started painting what I saw and people just wanted the paintings."

ESTABLISH GOALS

Many artists begin with small goals and aspirations; then they find that they love the challenge of reaching out to an ever-increasing art market. Others start out wanting national fame, and find that the greatest satisfaction for them is in doing the work and sharing it with a small number of friends.

Set realistic goals. "This year I will sell three paintings. Next year I am going to be accepted for the American Watercolor Society Show." Remember, goals are only there to give you focus. They never measure your success as a person or as an artist.

MAKE THE COMMITMENT

There is no one way to be a successful professional artist. Every artist finds her own way and her own market. Don't worry about that now. Just decide if becoming an artist will add significantly to the quality of your life. Simply, is this something you want to do? If so, make the decision and make the commitment to being an artist. Once you make that commitment, all else will follow.

EXERCISE: BEING AN ARTIST

Here are some questions to help you decide if you should be an artist. Answer true or false. Answer quickly. Don't take the time to analyze each question. Answer spontaneously and you will get a better sense of your actual feelings, not what you think you should say or what other people would want you to say.

I dream about being an artist. _____

I feel happy when I paint/sculpt. _____

I like to visit art museums. _____

People who make art are special. _____

I buy books about art. _____

People tell me I have talent. _____

Rooms look empty without art. _____

I would like to spend more money buying art. _____

I would like to see my art hanging on walls. _____

I subscribe to art magazines. _____

Artists have more fun than other people. _____

I like shopping in art supply stores. _____

I have always been fascinated with colors. _____

Kids should study art in school. _____

I always read the art news in the paper. _____

My favorite people like art. _____

If a large number of your answers are true, you are thinking like an artist and should pursue your dream to be one.

EXERCISE:
CONFRONT YOUR FEARS

To help you learn what fears you have, complete the following statements. Go ahead—be honest, you don't need to show this to anyone. Just be true to yourself.

If I become an artist, I will have to _____

If I become an artist, I will only _____

If I become an artist, I will never _____

If I become an artist, no one will _____

If I become an artist, everyone will _____

If I become an artist, people will think _____

If I become an artist, people will be afraid _____

If I become an artist, I will lose _____

If I become an artist, I will have to give up _____

If I become an artist, my friends will _____

If I become an artist, my family will _____

If I become an artist, my life will be too _____

EXERCISE: CONSIDER HOW YOU'LL FEEL

One way I have found to decide if I really want to do something is to consider how I will feel if I don't do it. Complete the following questions:

If I don't become an artist, I'll never _____

If I don't become an artist, I'll have to _____

If I don't become an artist, I can _____

If I don't become an artist, I might _____

If I don't become an artist, I'll regret _____

If I don't become an artist, I'll be glad _____

If I don't become an artist, I'll think _____

If I don't become an artist, I'll wish _____

If I don't become an artist, I'll always _____

If I don't become an artist, I'll be able to _____

If I don't become an artist, I'll never be able to _____

If I don't become an artist, I'll feel _____

The most important of these statements is the last one. Be honest. How will you really feel if you do not become an artist? Sad? Disappointed? Do you want to feel that way for the rest of your life? Probably not—so let's get started!

Create a Support Structure

HOW TO GET STARTED SELLING YOUR ART

A support structure for an art career consists of four parts:

> *People* to advise, encourage and help you
>
> *Space* to do your art and business
>
> *Time* to do your art and business
>
> *Money* to keep the wolf away from the door

People

Choosing the people to help with your art career may be a bit more complicated than it first appears. You probably already have a core group of people in your life—spouse, lover, parents, kids, friends and neighbors. Will they be the ones who provide support and assistance for your art career? Not necessarily.

Most of these people don't know what it takes to be a professional artist. Even though they want to help you, they might not know what you need or how to provide it. Your support structure should include people who understand the art world, people who have more experience than you in the field and who can give you sound advice. These can be art instructors, dealers, framers, consultants and, most important, other artists.

OTHER ARTISTS

Find other artists you can meet with or at least talk to on a regular basis. Even after thirty years as a professional, I still find that my artist friends are crucial to my continued success. We share information about shows, books, galleries and supplies. We look at each other's art, offering constructive criticism— notice I said *constructive* criticism; you do not need anyone in your life who just says your work is bad. We share the expense of figure models and take painting excursions together.

Seek out artists who are more experienced than you. Be respectful of their time and attention, and they will usually be willing to help you in one way or another. They might give you suggestions about your work or career; they might provide introductions to other people who can help you; or they might just serve as role models.

Ask questions: Where do you show work? Where do you get your frames made? Do you know of any local art organizations? Where can I find figure drawing models? Can you suggest a good teacher?

One caution here—there is a difference between "asking" and "demanding." You are asking someone to give their time and information. Out of respect for them, be simple, honest and direct.

CLASSES AND WORKSHOPS

Art classes and workshops are excellent sources of support. Just talking to other students and the instructor during breaks can give you valuable information for pursuing your career. Don't be shy about telling people that you are just beginning your art career and you don't know what to do. Artists are especially generous with advice to each other.

ART ORGANIZATIONS

Art organizations such as watercolor societies, pastel societies and art guilds are extremely useful for the beginner. These are groups of people banded together in an effort to support their own and each others' art careers—just what you need. They usually have regular meetings, often with demonstrations by accomplished artists to help you learn new techniques. They organize art exhibits for members. They provide the opportunity for you to make new friends who are also artists, and to share your concerns about the art world.

You can find local art groups by looking in newspapers and magazines for civic or community listings of meetings and exhibits. Ask around at museums, schools, galleries and art supply stores. Art supply stores often have a bulletin board for posting events and resources, while salespeople may have a wealth of knowledge about the local art scene.

YOUR DECISION AFFECTS OTHERS

Sue Dawson, wife of nationally known pastel artist Doug Dawson, cautions that it is easy for artists to think they are the only ones making sacrifices. Sue points out that the whole family makes sacrifices. Be aware when you decide to be an artist that your decision affects everyone close to you.

Agents

CHECK REPS OUT

A word of caution: Be very careful about handing your art over to strangers, especially if they don't have an established place of business. Get references. Get agreements and records of consigned art in writing. Phone and visit so you know what they are doing and where your art is.

I have taught many workshops on art marketing over the years and in every one someone asks me how to find an agent. The truth is that agents for fine artists are rare; good agents are almost impossible to find. I advise artists that their time and energy can often be used in better ways than trying to find an agent.

WHAT AGENTS DO

An agent, manager or art "rep" is someone to help you plan and manage your career. A good agent will arrange exhibits, find buyers, find galleries and get publicity. In return the agent will get a percentage of your art sales.

Agents may be listed in the phone book or in art publications, but the best way to find them is through word of mouth.

The reason there are so few agents for fine artists is a lack of money. Most agents are paid a percentage of sales. It usually takes years for an artist to get to the point where sales bring in a significant amount of money; by then the agent will have starved to death. As a result, not many people who know much about art become agents; they find a more lucrative career in art.

Occasionally a person who doesn't know about art will decide to be an artists' agent. The problem with them is it takes them some time to learn about the art business; in the meantime they are not doing you much good, and may actually be harming your career.

ART BUSINESS CONSULTANTS

The situation is not totally hopeless. There are some art reps you can hire by the hour. Usually they are called art business consultants or art marketing consultants. These are people whose art expertise can help you make a more professional presentation or save some steps in your career.

These consultants usually advertise in art publications or the phone book. Before you hire one, think about what you want them to help you accomplish. Their rates are usually fairly high, so you don't want to waste time with them. Ask for their credentials—what they have actually achieved for others—and ask for the names and phone numbers of other artists they have worked with. Anyone can call himself a consultant; be sure the consultant can deliver what he promises.

What specific things can consultants accomplish for you? Some can help you design publicity materials—brochures, résumés and portfolios. They might help you meet art dealers and important figures in the art world. They might get your art exhibited in university and museum exhibits.

Many consultants teach workshops on art marketing. These classes can be a good way of getting information about conducting your art business, and also a way of finding an art rep.

AGREEMENT WITH AGENT

You should define your working arrangement with an agent or other art rep in a written agreement signed by both of you. The agreement should cover the following details:

1. Where will the agent represent the artist? (city, state, country?)
2. What is the time period? (beginning and ending time)
3. Is this an exclusive arrangement? Can the artist work with other representatives?
4. How will the agent be paid? (A percentage of any work the agent sells? A percentage of any work the artist sells? An hourly fee?)
5. How can this relationship be ended?

EXAMPLE

This agreement stipulates that _____*agent*_____ will represent _____*artist*_____ for the selling and promoting of art within the state of Colorado from June 1, 1996, until June 1, 1997. The artist will not work with any other agent during this period, but may work with galleries and other art dealers exclusive of the agent. The agent will be paid ten percent (10%) of all sales from exhibits or direct sales initiated by the agent. Prices will be set by the artist. Art will remain the property of the artist until full payment is received. The artist will be paid within thirty (30) days of sale. This relationship can be ended with thirty (30) days notice by either party.

_____ _____
artist *agent*

date

OTHER REPS

There are other kinds of reps who can help you with some segments of your career. These are art consultants, interior designers, architects and private dealers. They often deal with corporations, other businesses or individuals who want large quantities of art for new or redesigned offices or homes.

These are professionals who handle art but usually don't have galleries. They keep a portfolio of slides and other information about several artists. Whenever a client or a job calls for a particular type of art, they will contact the appropriate artist in their file.

You can find these people listed in phone books. Call and ask if they would be interested in seeing your art for possible representation.

TRAIN YOUR OWN AGENT

If you have a friend or acquaintance who is interested in learning about the art world, who would like to help you out and who doesn't care about making a lot of money right away, they might become your rep. The qualities to look for:

- They should look professional.
- They should speak well.
- They should not be shy.
- They should know something about art and business, or be willing to learn.
- They should be responsible.
- They should work hard.

I've known several successful artists whose business managers were their spouses, either husband or wife. The advantage of this relationship is that you are both able to share the art career that takes so much of your time and energy. The biggest disadvantage is that if you have any problems already existing in your relationship, they will be intensified by sharing your art career. Artist and agent must trust and respect each other fully.

BE YOUR OWN AGENT

In most cases the best person to be your agent is you. No one else cares more about your success; no one else knows more about your art or your goals. At first you might feel shy or awkward about presenting your art to collectors or dealers. Be patient with yourself: In time you will learn to do it smoothly and effectively.

One thing that helps is to think of promoting and selling as the steps you go through to share your art with other people. Whether an agent does it or you do it yourself, it's how you share your art with the world.

Family and Friends

Now, back to those folks who are already in your life. They are also extremely important. They can support your career with everyday kindness and attention that lead you from success to success or they can put up roadblocks at every turn.

In each of our basic relationships we achieve a type of balance. We know pretty much who is going to do what and how the others are going to react and how we can compensate to keep all our lives running smoothly. Psychologist John Bradshaw uses the example of a mobile to show how families are interdependent. Balance depends on each person doing certain things. If one piece is moved out of place, it causes all the others to move as well.

Your life will change drastically as you become a professional artist, but what you might not realize is the profound effect it will have on everyone around you. Your friends and family will need to provide more support. At the same time, you will not be as readily available to support others because of the demands of your new career.

Most people who realize how important your goal to be an artist is will gladly help in whatever way they can. You may need to sit down with each member of your immediate circle and explain what it is that you are proposing to do with your life and why it is important to you. I have found that many peo-

ple love to be included in an adventure, especially someone else's adventure. Explain how exciting art is to you, the possibilities of success, the likelihood of some rejection and the hard work involved. Most people will be delighted to provide whatever support they can.

However, some people won't be supportive. They may be jealous that you are taking time away from them, or afraid of the hard times you might be facing as well as the hard times they might be facing as the husband/wife/child/parent of an artist. Be sensitive to what people around you are thinking and feeling.

POSITIVE AND NEGATIVE INFLUENCES

Identify the people who are most committed to your career. They are the ones you can turn to for help with moving your sculptures, addressing invitations, baking cookies for a show or just cheering you up when you feel overwhelmed.

Also identify the negative people. These people can destroy your career before it even gets started. Reassure them. Let them know you care about them, and your art career will not change that. It's OK if they don't help you, but it's not OK for them to obstruct your progress.

You need people whose wholehearted support and enthusiasm can always be counted on.

IMPACT OF OTHERS

People impact your progress as an artist. Any success I have is the result of many people's efforts, not only my own: Friends, family, framer, photographer, art dealers and publishers, as well as my chiropractor, financial advisor and auto mechanic—everyone who makes life run smoothly.

You may think this structure has nothing to do with the marks you put on canvas, but believe me, it does.

Success Story

Your Art Coach

It's Your Call

I believe that for every serious endeavor we undertake it is valuable to have a coach. In the business world this person is called a mentor, but I prefer the image of a coach.

Ideally, you have or will find someone who is knowledgeable about the art world to give you guidance. However, many effective coaches are not experts about art. They can be people who know about business or just have good common sense. Most important, they have to be committed to your success. Often two artists can be coaches for each other, but be sure to choose someone who is committed to success—yours as well as their own.

WORK TOGETHER AS A TEAM

Sit down with your coach and discuss what your dreams and goals are. Put them on paper. Start out with small goals, like spending more time painting. Then draw up plans to reach them. Plan a schedule for the next week that will give you time to paint. Be very specific. Write the painting times on your calendar and give a copy to your coach. Then commit to particular times when you

will call your coach and report on your progress. Reporting to someone else seems to make the whole process more important.

QUALITIES TO LOOK FOR IN A COACH

Three qualities that are most important in an art coach:

- The coach must be practical and concerned about everyday activities that will lead to your art success. Dreams and philosophy are wonderful, but day-to-day work is what's going to bring success.
- The coach must be genuinely committed to your success. It is no good to have someone around who says you can be successful but really believes you are doomed to failure. The coach must believe that your art career is important.
- The coach must be available to you. The coach must be there for a scheduled meeting or progress report. There also has to be a way for you to get in touch in the event of a crisis or something unforeseen coming up.

Space

Most artists dream of a wonderful, big studio for creating and storing art, for entertaining friends and prospective collectors, and for keeping files, a computer and all the other paraphernalia needed to run a business. Reality is usually much less.

What you really need is space to make art. I used to carve large woodblock prints on the dining room table. It wasn't convenient, but it worked. That is the bottom line—does it work?

Think about what kind of space you need to create your art. Someone who paints large oils will need more room than someone who paints small watercolors. A photographer has different needs than a sculptor, ceramicist or pastel artist.

In your mind, go through the process of creating your art, and write down the space you need for each phase. Divide it into two categories: (1) storage and (2) work space.

STORAGE

What do you need for storage? Let's say you are an oil painter. You need a shelf or cupboard to store your paints, brushes and solvents. You need space to store reference material—photos, sketch books and still-life supplies. You need a place to store your wet palette and wet canvases. You need a place to keep your easel, dry canvases and frames. You also need space to store your business records, ledgers, mailing list, photographs and so on.

WORK SPACE

What do you need for work space? You need a table or taboret to set out your paints, brushes, paper towels, medium and palette. You need space for your easel. You need space to set up a subject and/or tack up studies. You also need good light and ventilation.

FIND YOUR SPACE

Write all your storage and work space requirements down. Then you can figure out what space you need. If money is no object, go ahead and rent or build a studio that will meet these needs. If funds are limited, you have to be a bit more creative.

First, what space is not used in your home? Is there an extra bedroom, garage or storage room? Is there part of a room that is not used? Even a corner of a room can be converted into a perfectly workable studio. Space can also be used for double purposes, like the dining room table I carved woodblocks on. Where you do the art doesn't matter: The important thing is that you are creating art.

Do you know someone who has space that they are no longer using—maybe a friend's basement or a neighborhood business? A printmaker I know found a large basement room behind the laundry room in an apartment building. The owner of the building couldn't use the space for much besides storage; he was happy to rent it to her at a nominal fee for an etching studio.

DO YOU REALLY NEED A STUDIO?

No. It's great to have one, but a studio is not what makes you an artist. What makes you an artist is creating art. Always hold that thought and don't let the lack of a studio or any other stumbling block become a reason to not create art.

It's Your Call

A CREATIVE EXERCISE IN FINDING SPACE

Still having trouble finding space to do art and store materials? Walk through your house or apartment room by room. Take a pad and pencil with you and jot down any possible space, no matter how small. Then jot down any ways you might use that space. Let your imagination run wild—don't worry about being realistic with this exercise. Do it once for fun, and then go back through your house more seriously. You'll be amazed at the ideas you come up with!

ANOTHER OPTION— BUY A BUILDING

Artists are well known for renting old, unused industrial space. With a little money and a lot of work, the artists convert what had been worthless space into attractive studios and lofts. Other people, including landlords, see how attractive the space is now and suddenly the rent goes up so high that the artists can no longer afford to stay there.

Phil Salvato, a painter looking for a studio in the Pittsburgh area, found a large space on the third floor of an old, run-down building. Instead of renting, Salvato decided to buy. He talked the owner into carrying the mortgage. He refinanced his house and used all of his savings for the $20,000 down payment and money to start renovating.

It was a gamble for the artist and his wife. They lived from painting to painting, learning to be landlords and learning to be building contractors. After just five and a half years they own an attractive building that houses his studio, a frame shop and a gallery—and no one can raise their rent.

Salvato says, "The whole thing was done on faith. The first step has to be taken—and then just don't stop."

Time

Everyone seems to complain they don't have enough time. There is always enough time, however, to do something you really want to do.

MAKE TIME FOR YOUR ART

Creating art may seem like something that you can always put off for later. Change this attitude immediately. If you are to be a professional artist, you don't have to spend eight hours every day producing art, but you do have to produce art consistently.

Decide how much time you can realistically devote to art, and make those hours the most urgent part of your schedule. That time should not be sacrificed for any reason. If you absolutely cannot paint today, then reschedule those hours for tomorrow. Never allow a week to pass without devoting your hours to creating art.

PRIORITIZE AND PLAN

Shortage of time is not usually a problem, but a lack of organization is. There are two ways to maximize your time: Prioritize and plan. Prioritize by deciding which are the most important things to do. Plan by fitting those things most efficiently into your available time.

PRIORITIZE

Begin to prioritize by listing all the things you would like to accomplish during a given period of time. For example, today I would like to:

- do my laundry
- buy a birthday present for my sister
- start a new painting
- buy some flowers to use as a painting subject
- go to the art museum
- balance my checkbook
- mail my application to the pastel show
- order frames for the paintings I finished last week

Now decide what things can be done another time. Laundry? No, I'm out of underwear. Buying the present? Yes. I don't need it until Saturday. Start a new painting? No, I haven't painted for three days. And so on. All the items that don't need to be done today can be moved to another day's list. Number the remaining items in terms of importance. Do this for each day of the week. I've included worksheets at the end of this section so you can get started on this right now.

NOT SELFISH— SMART

One way to create more time in your life is to stop doing things for people that they can do themselves. You can also hire people to do things that keep you from your art. Let someone else clean the apartment or mow the lawn. Sound a little selfish? Yes, it is . . . but by being selfish about your time, you can make an invaluable contribution to the world— your art.

PLAN

Now that you've prioritized your activities, it's time for creative planning. First you have to fit activities into a 24-hour period. Make seven charts, one for each day of the week, with twenty-four lines designating one hour each on each chart. This represents the entire week. Start filling in the lines with essentials, such as sleep, meals and showering.

Now check your priority list and fill in lines for all the items on it. Do you find yourself with more activities than time? Go back to your priority list and see if anything can be eliminated or postponed. Also see if there is anything you can do faster: Maybe serve pre-cooked meals once or twice a week, or cut your exercise time down to half an hour a day. Remember to be realistic. Don't eliminate anything that is essential to your health and well-being, or that of your family.

Do not, however, cut down on your art time. Be patient and imaginative with your time. You'll find a way to fit in the essentials.

SCHEDULE YOUR DAY

Now that you have prioritized and planned your activities into 24-hour segments, scheduling each day is relatively easy. Simply take each item from your 24-hour list and place it in your daily schedule in the most efficient way. Buy or make a calendar so that you can continue this orderly scheduling on a regular basis. There are several commercially available time management systems that can help with this.

MYTH VS. REALITY

Prioritizing and planning doesn't sound like the glamorous life of an artist. The myth is that an artist just wanders into the studio whenever inspiration strikes and spends the rest of her time sitting around drinking wine. Being an artist does have its glamorous moments, but they have to fit into the reality of day-to-day living. In order to have glamorous moments you have to have time, and that comes as a result of using your days wisely. After all, without the time to make the art there is no art to sell.

Creative Time Management Examples

THE SITUATION

Let's look at a typical situation. A mother of young children has delayed her art career for seven years now. She is cross and irritable with her husband and children because she feels there is never any time for her own life—every day seems to be jam-packed with taking care of the family. She finally decides that she can take one hour a day to work on her art.

THE CHALLENGE

The first day the baby has a cough and she can't leave him alone, even for an hour. The next day there are teacher-parent conferences at school. The third day there are doctor appointments and Little League. One hour a day doesn't seem like much, but even it is not working out.

A CREATIVE SOLUTION

One hour a day can also be looked at as seven hours per week. What if the artist's husband watches the kids for three and a half hours on Saturday and Sunday? Any compromise that allows seven hours per week for her to pursue her dream provides a solution.

ANOTHER SITUATION

An executive wants to spend two hours a day on his sculpture, but he can never seem to find more than one hour.

MORE CREATIVE SOLUTIONS

His daily commute takes an hour during rush hour. He finds that by leaving his house one hour early he saves thirty minutes in the morning. He rents an art studio close to his office. After work he goes directly to the studio. After two hours in the studio he drives home, again missing rush-hour traffic and saving another half hour. He has creatively found two hours for his art every day.

SCHEDULE TIME TO PAINT

Mel Carter has attained international success—while teaching. He's painted all over the world and exhibited widely, including a solo exhibit in Vienna. He's taught for twenty years at Community College of Denver and the Art Students League of Denver. His numerous honors include the Fulbright Award.

Carter says, "I never thought I would be a successful artist. I knew I would be a good teacher, but I would burn out as a teacher if I didn't also paint. So I set up a schedule of painting twelve hours every week. Also I looked for every venue I could find to exhibit my work."

Success Story

EXERCISE:
PRIORITIZE

List all the things you would like to get done on each day of the week.

_____ _____

_____ _____

_____ _____

_____ _____

_____ _____

_____ _____

_____ _____

_____ _____

_____ _____

_____ _____

_____ _____

_____ _____

Go back through your list. Whenever you find a task that could be done on a later day, cross it out and move it to that day's list. When you have eliminated anything that is not urgent for that day, number everything on the list in order of importance.

EXERCISE:
PLAN

The following chart has twenty-four spaces, one for each hour of the day. Assign spaces for each of your regular daily activities. Then add as many items as will fit from the priority list. If you have too many activities to fit into the spaces, eliminate or shorten activities until they fill the twenty-four hours. Don't forget time for the basics like eating, sleeping, brushing your teeth, driving and talking on the phone.

(ONE HOUR FOR EACH SPACE)

_____ _____

_____ _____

_____ _____

_____ _____

_____ _____

_____ _____

_____ _____

_____ _____

_____ _____

_____ _____

_____ _____

EXERCISE: SCHEDULE

Once you have organized your activities into 24 hour segments, scheduling each day is relatively easy. Simply take each activity from your 24 hour list and place it in your daily schedule in the most efficient way. Buy or make a large calendar so that you can continue this orderly scheduling on a regular basis. There are several commercially available time management systems that will help you continue this kind of time structuring.

DAY OF THE WEEK

A.M.

12:00 _____

1:00 _____

2:00 _____

3:00 _____

4:00 _____

5:00 _____

6:00 _____

7:00 _____

8:00 _____

9:00 _____

10:00 _____

11:00 _____

P.M.

12:00 _____

1:00 _____

2:00 _____

3:00 _____

4:00 _____

5:00 _____

6:00 _____

7:00 _____

8:00 _____

9:00 _____

10:00 _____

11:00 _____

Money

The last part of your support structure we need to discuss is money. Money is often a difficult subject. Even when we have plenty of it, we sometimes feel guilty spending it on something as frivolous as the dream of an art career.

The first step in considering the role money plays in your support structure for an art career is to look at how you feel about it. Can you function without a firm sense of financial security? Do you need to know there is enough money to pay the bills and save for retirement for your own peace of mind? If this is the case, you need to create a structure where you will feel comfortable but not give up your art due to fear of financial problems.

POSSIBLE EXPENSES

It is impossible to know exactly how much money you will need for your art career, but you can, and should, estimate a monthly budget. Be comprehensive. Use this list as a start for determining what your own needs will be.

- Art supplies—paint, pencils, canvas, paper and brushes
- Studio supplies—easel, tables, lights, extension cords and air filter
- Good shoes for standing in studio
- Cleaning supplies—soap, paper towels, cleanser, mop, broom and sponges
- Business supplies—typing/computer paper, envelopes, pens, notepads, file cards, filing cabinet and file folders
- Framing supplies—mat board, molding, framing equipment or framing services—the cost of hiring a framer
- Utilities—additional phone and electrical expenses
- Subscriptions to newspapers and art magazines
- Dues and entry fees for art organizations and exhibits
- Additional parking costs—studio, galleries and museums
- Tickets to museums
- Postage and shipping
- Travel—for painting research and visiting galleries and museums
- Photography—camera, lights, film, processing or a photographer
- Printing—cards, stationery, invitations, brochures and greeting cards
- Entertaining collectors and other artists

Success Story

JOBS

A job to help support your art career does not mean you are a failure as an artist; it just means you are being sensible about money. A steady job allays financial stress, but takes a considerable amount of time and energy. The trick is to find the right balance between the job and your art. You can work days and paint evenings; work nights and paint during the day; work weekdays and paint weekends. If your job is taking so much of your time and energy that you are unable to produce art, then you have to be willing to look for a different job.

As you proceed with your art career, you will be earning more of your income from your art. However, it is impossible to predict when the art income will exceed the expenses, especially since your expenses will increase as your work becomes more in demand. Find a job you can live with and be patient about earning art money.

TIME TO QUIT YOUR JOB? ONE ARTIST'S STORY

Doug Dawson taught art in a junior high school in Denver for six years while painting nights and weekends. He exhibited and sold his art for five years, and wanted to be an artist full time. He knew it was risky. He had a wife and two young children to support, as well as himself. He decided to go ahead and quit.

Dawson says, "We had been saving for this. We had enough money that we thought we could live for six months. We had also stored massive quantities of canned string beans and toilet paper." Dawson's work began to sell well at a local gallery and he felt confident of his budding art career, when suddenly the gallery went bankrupt—owing the Dawsons several thousand dollars. At the end of a year he went back to his teaching job.

He says, "I taught for a month. Then I decided I couldn't do it anymore. Since then we have survived. Sometimes we look back and wonder how we did it. I taught part time and Sue worked part time, but mostly we managed on my art. We even put two kids through college."

ART FULL TIME

Some aspiring artists save enough money to live without other work for one or two years. They decide to be full-time artists for that amount of time, and if they don't "make it," they give up art. I don't agree with this kind of rigid goal and deadline. If you put too much pressure on yourself to be self-supporting from your art, it will interfere with your creativity and may eventually destroy your art career.

Art is a business. It is pretty unrealistic to think that you can become self-supporting from any new business in just a year or two. Actually, art is two businesses—creating a product and selling that product.

A major reason businesses fail is that they are under-financed; the proprietor has enough money to get started, but not enough to keep the business going for a sufficient length of time. Don't close your eyes to the issue of money: It is a very real need for artists. An art career is a voracious creature; it will consume any amount of money you can afford to put into it.

Besides your basic living expenses, you need art supplies, and then as you become more successful, money for crating and shipping, traveling, exhibit fees, promotion and so on.

CUT YOUR EXPENSES— A CREATIVE EXAMPLE

There is a myth that you have to live where the big galleries and museums are in order to be a successful artist. It's not true.

Italian artist Benini was in Fort Smith, Arkansas, for an exhibit of his art. He and his wife, Lorraine, took a wrong turn driving through the state and came across the town of Hot Springs. They found a row of wonderful old brick buildings sitting empty on the main street of what once was a thriving tourist town. In less than a day, they bought a building for a very small amount of money. They moved in and renovated the building, with studio and living quarters upstairs and exhibition space on the ground floor.

Gradually their friends were also attracted by the beautiful surroundings and low cost of living. Within a few years the area became a thriving art center with many professional artists and half a dozen sophisticated galleries, all able to survive more easily in this area, where the cost of living was more manageable, than in a major urban center.

BE PATIENT
Once you make the commitment to succeed, the money will be there one way or another. It might take longer and you might have to work harder than you would like, but you will find the money. Simplify your life by starting out with some kind of financial structure.

It's Your Call

WORKSHEET: SUPPORT STRUCTURE

I can't emphasize enough the importance of the support structure we've talked about in this chapter. But just reading about it or understanding it is not enough. In order to proceed with a career as a professional artist, you need to assess your support structure right now and then determine how to solidify it. Use this worksheet as a guide; fill in the blanks here or on another sheet of paper.

People

Artists you know and ways of meeting artists _____

Classes and workshops _____

Possible art coaches _____

People close to you now and how you think they'll react to your career _____

Space

Space for storage _____

Space for work space _____

Creative ideas for finding space _____

Time

Complete the worksheets in this chapter _____

Creative solutions to your time restrictions _____

Money

How you feel about money and what impact your feelings will have on your art career _____

Possible art-related jobs you might do to support your art career _____

Create a support structure based on these four components, to make your success as a professional artist quicker and easier:

1. PEOPLE
 - Art friends—Make friends who share your interest in art and are knowledgeable about the art world. Art classes and clubs are good sources of art friends and information.
 - Agents and business managers—There are people who help you plan and manage your career for a percentage of your art sales or a fee. Agents for fine artists are rare. A friend or acquaintance can be your business manager, with the proper training and skills. The best person to be your agent is you.
 - Family and friends—Your career will impact everyone around you. The entire family will make sacrifices for your career, so be sensitive to their needs too. Don't be shy about asking for help.
 - Art coach—Find an art coach who is committed to your success.

2. SPACE
 - When planning your space, keep three things in mind:
 Storage space
 Work space
 Special needs
 - Be creative in adapting your surroundings to space where you can create art.

3. TIME
 - Maximize your time by:
 Prioritizing, planning and scheduling
 - Make a commitment to devote a certain number of hours each week to your art, and do not sacrifice that art time for any reason.

4. MONEY
 - Find a regular source of income rather than constantly worrying over money. A job doesn't mean you are a failure as an artist.
 - Don't burden yourself with unrealistic deadlines for financial viability. Be patient and keep producing art.

Chapter Summary

2

Prepare to Sell Your Art

Most of us would like some authority to give our art a stamp of approval: "It's now good enough to show and sell." That would be very reassuring. Who can you trust to make that decision? Only one person: You. The only opinion that really matters is your own.

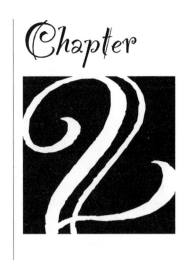

Chapter

Sell Your Unique Expression

One of the worst pitfalls for professional artists is trying to paint what sells. Yes, there are subjects and styles that seem to be more popular than others, and some artists devote a lot of energy to keeping up with the trends. For example, landscape and floral paintings are easier to sell than figurative work. Realistic work finds a market easier than abstract art.

Beware of people who tell you what to paint or what will sell. Art dealers, especially, like to tell you what to produce. In California they want you to paint eucalyptus trees; in Arizona they want you to paint cactus. The problem with painting for other people is that you lose the spontaneity of your expression. Instead of exploring the joy of color and design, you are constantly worrying about what other people will think. You don't have to make what is popular in order to sell. Paint what you want to paint rather than copying more successful artists. Buyers respond to sincerity. Your art will have a unique power that is lacking in copies if you care about your subject. If it doesn't sell one place, it will sell someplace else.

PAINT WHAT'S TRUE

If you paint what you really care about, you will find a market for it. Expressionist Warren Criswell is certainly proof of this maxim.

Criswell says early in the 1960s he had "good success" selling his Abstract Expressionist-type canvases. Then he dropped out of the art scene to write. In the 1970s he and his wife traveled around the country until their bus broke down—and he decided to resume his art career.

However, he didn't go back to his early, successful abstract painting style. He painted photorealistic landscapes in watercolor. He took them to a gallery to be framed—and the dealer asked to exhibit them. The new work was successful.

"Somewhere along the line," he says, "I switched to pastels and oils and my things started getting darker. I did a series of homeless people and I lost all my original buyers. Every time you change anything you run that risk."

He found new collectors, then changed his work again. He says, "I painted my 'Feet Suite' where I was looking down at only feet, and then started an artist-and-model series. In 1991 they got very psychological." New people bought the work.

Now he is painting large introspective pieces, often using himself as the model for nude figures. You might expect that with this new, very unconventional work he would have finally found something for which there was no market, especially in rural Arkansas, which is his home. You would be wrong. These aggressively original pieces sell regularly and quickly.

His collectors think he is a genius and agree with him when he says, "Art is not anything if it's not truthful."

BE OBJECTIVE ABOUT YOUR ART

Learn to see your own art objectively. One day it may look great to you and the next day it looks terrible. If you wait until your art is the best that it can ever be, you will never show it. Perfection isn't necessary and perfectionism is often just an excuse to avoid taking action.

TIPS FOR JUDGING YOUR ART

- Never judge *all* of your art. Look at one piece at a time.
- Don't judge a piece when you first finish it. Put it away or turn it to the wall for a week or two before you decide if you like it.
- Don't worry about what others will think. Is it pleasing to *your* eye?
- Don't worry if it is good enough to hang in the Metropolitan. How will it look in someone's home?

SIGN YOUR ART

Your signature is an important part of the art. It should be clear enough to be easily read, but not so dominant that it upsets the balance of the painting. It should look as smooth and spontaneous. When you start writing your name with a paintbrush, the letters might look broken and awkward. Practice painting your signature onto blank paper or cardboard until the painted signature looks smooth.

Some artists add a copyright symbol to their signature. I don't, because viewers might think they're looking at a commercial print rather than original art.

I stopped adding the date to my signature when I realized that collectors may think there is something wrong with a painting that hasn't sold in the first year. I record the date in my files or on the back of the piece.

Some artists add letters after their signature to connote membership in a prestigious art organization such as the American Watercolor Society (AWS), National Academy (NA) or Pastel Society of America (PSA). Membership in these organizations is generally difficult to achieve and indicates a certain level of artistic skill; however, I think it is more appropriate to put that information on your résumé rather than on the painting.

DO YOU HAVE ENOUGH WORK TO SHOW?

How much work do you need? I've heard many different numbers. There is no magic number. You need as many pieces as it takes to prove that you are a committed artist with an acceptable amount of technical skill.

Some people think your body of work must have a common theme or subject. Don't worry about that when you are beginning. As a beginner, you should explore new subjects and new styles. Eventually your own vision will evolve.

How Much to Charge

NOWHERE BUT UP

Keep in mind that you can always raise your prices, but you can never lower them, because that lowers the value of what your collectors have already bought and destroys your market value.

Pricing is a difficult issue for beginners. Charging too much often results in no sales at all, yet you may be afraid that charging too little will undermine the value of your work.

PRICE TO SELL

Start out charging as little as you possibly can. The most important goal is selling. Established artists can command the prices they ask in galleries because they have already received those prices from collectors. You are starting out from zero. At your first show keep all of your prices under $100—even under $50. Your success will eventually be established by the amount of art you sell. In the beginning, people may want to buy your art just because it seems like such a bargain. That's great. The people who buy your art at the beginning will become the foundation for your entire career. They are becoming your collector base, and you are becoming an artist who is collected. Sales at any price are a wonderful boost to your confidence as a professional artist.

What about covering expenses? At this point you are investing in building a following and, eventually, a demand for your art. You can gradually raise your prices as you establish a reputation. It is standard business practice to operate in the red at the beginning in order to build a future market.

PRICE CONSISTENTLY

Arrange your pieces by size and medium. For example, all 22″ × 30″ watercolors should be one price, 15″ × 22″ watercolors should all be one lower price, and so on. The smaller the piece, the lower the price. Works on canvas are traditionally higher than those on paper, so an 8″ × 10″ oil painting should be slightly higher than a watercolor of the same size.

Artists creating multiple images (such as printmakers, photographers and some sculptors) should adjust prices according to how many images are available. Pieces from an edition of fifty should cost less than those from an edition of ten.

PRICING WORKSHEET

List all your art of one medium. Start with the largest pieces, working gradually down to the smallest. Fill in prices. All pieces of the same size should have the same price. The largest pieces should have the highest prices, the smallest should have the lowest.

Medium _____

Date _____

Title	Size	Price
_____	_____	_____
_____	_____	_____
_____	_____	_____
_____	_____	_____
_____	_____	_____
_____	_____	_____
_____	_____	_____
_____	_____	_____
_____	_____	_____
_____	_____	_____
_____	_____	_____
_____	_____	_____
_____	_____	_____
_____	_____	_____
_____	_____	_____
_____	_____	_____
_____	_____	_____
_____	_____	_____
_____	_____	_____

Presenting Your Art

PROFESSIONAL FRAMERS

Some professional framers have reasonable prices and do excellent work.

- *Give a new framer one or two pieces at first, rather than a large order.*
- *Ask for suggestions, but always make judgments based on your own taste and needs.*
- *Always insist on "conservation framing" for works on paper. All materials touching the art should be acid free.*

MATTING AND FRAMING

Matting and framing are more than just ways to hang art on the wall. A good presentation announces that this is a work of art worth looking at and buying. There are entire books devoted to framing, so I'll give only a few guidelines here.

1. Make your presentation simple.
 - Plain, neutral mat board enhances art and complements a variety of decors.
 - Metal sectional frames are a good, inexpensive alternative for works on paper and moderate-size canvases.
 - Strip frames are a low-cost alternative for canvases. These are made by nailing a thin strip of painted or varnished wood to the edge of the canvas. Be sure that the corners are neatly joined.
2. Make your presentation professional looking.
 - Insist on straight, clean-cut mat edges and tight-fitting frame corners.
 - Secondhand or recycled frames should be clean and undamaged.
 - Use mats that give a comfortable space around the artwork, usually about three inches.
3. Make your presentation protect and preserve your art. Works on paper are especially fragile.

- Always use acid-free materials for anything that touches the art.
- Separate art from glass with a mat or spacer. This will help minimize mold and moisture problems.
- Consider Plexiglas for watercolors. It eliminates a large percentage of the ultraviolet rays that cause fading.
- Avoid Plexiglas for pastels. It creates static electricity that pulls pigment off the surface.
- Be sure that screw eyes, wires or other hangers are secure and strong enough to support framed art.

PRESENTING SCULPTURE

Sculpture, particularly cast sculpture, presents a special problem to the beginning artist. Unless you have large financial resources, it is difficult to pay for casting several pieces of work in bronze. If you are preparing your first body of work, it is acceptable to cast only a few pieces in bronze. You can show others in the wax models, taking precautions for the fragility of wax, or you can cast some pieces in less expensive substances (aluminum, plastics and even plaster). All pieces, even wax or plaster, should be presented on professional-looking bases.

Taking Care of Business

A most important component of your career is keeping records. Devise a plan from the very beginning for keeping track of your art income and expenses. A simple method is to use two notebooks, one in which you list all of your art expenses and another for your art income. This is so important that I've included charts on the following page that you can photocopy.

You can also use an accordion folder for various categories of business expenses. At the end of the year you can add up all the receipts from each category and have an accurate record.

If you have a computer, use a program like "Quicken" that easily organizes all of the money going out and coming in.

A SEPARATE ACCOUNT

It helps to open a separate business checking account just for your art career; then all of the checks you write on that account are related to art. If you pay art expenses with cash, be sure to save the receipts, besides writing the amounts in your expense notebook. Save receipts for your checks as well.

ART INVENTORY

At first, it's easy to keep track of all your art in your head—but that quickly becomes impossible. Here is a simple way to keep your art inventory straight: For each completed art work make one index card. Attach a slide or photo of the work to each card and include the following information:

- title
- medium
- size
- date completed
- subject
- photographed?
- framed?
- current location
- previous shows
- date sold
- buyer

Keep all cards of unsold work in one file and move the cards for work sold into a separate file. To access the work easily, arrange cards alphabetically by title. In addition, keep a list of all works by date.

SALES TAX

Long before you show your work, you should explore sales tax regulations. In most locations you're required by law to collect and pay the city and/or state, sales tax on art you sell. To find out specific regulations, contact your local government. You'll be required to apply for a sales license. The advantage of a sales tax permit is that it allows you to purchase art supplies for resale. This means that you don't have to pay sales tax on supplies you use for goods to be sold, such as your paintings. This can add up to a substantial savings for you.

CREATE A SYSTEM

Record or store your expense receipts on a daily, or at least weekly, basis. Some artists throw every receipt in a shopping bag until the end of the year and then try to organize them. It can be done, but it eventually produces an enormous headache. Do yourself a favor and create some type of record-keeping system.

Hot Tip

INCOME/EXPENSE CHART

INCOME CHART

Date	Item sold	Buyer	Price	Cumulative Income

EXPENSE CHART

Date	Purchase	Cost	Seller	Category

Regularly tabulate your expenses by category—supplies, shipping, promotion and so on.

SELLING YOUR UNIQUE EXPRESSION
- When is your work good enough to show? When you decide it is. Do the work you love, and trust that there will be a market for it. Learn to see your art objectively.

SIGN YOUR ART
- Your signature is an important part of your art.

HOW MUCH WORK DO YOU NEED?
- You need as many pieces as it takes to show that you are serious and competent.

PRESENTING YOUR ART
- Make your presentation protect and preserve your artwork in a simple and professional way. Presentation shows what you think of your own work.

PRICING TO SELL
- Charge as little for your work as possible in the beginning, in order to sell it easily. Your most important concern is building a collector base. Price your art consistently according to size and medium.

TAKING CARE OF BUSINESS
- Start now to keep records of your expenses and income. Devise a record-keeping system, no matter how simple it is. Contact your state and city governments for tax regulations. You will be required to apply for a sales license.

Sell Your Art at a Home or Studio Show

You don't need to wait for someone else to show and sell your art: Launch your own art career with a home or studio show. Ultimately, you are the one responsible for getting your art to the public, and I firmly believe giving your own show is the best way to do that.

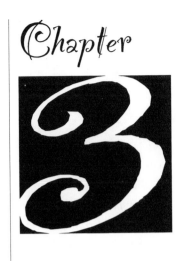

Chapter

3

Your Own Show

AVOID TAX DEADLINES

Many people think the entire block of time between New Year's and April 15 is a bad time to buy or sell anything. Take that into consideration when choosing a date for your show.

PICK A DATE

The first thing you need to do to plan your own show is choose the date. There are a number of considerations to take into account when you set the date. First and foremost, definitely have all the art finished before you set the date. This is crucial. As your show approaches, you will feel more and more stress. That pressure will make it harder and harder to judge your art objectively. Also allow plenty of time to get your art framed: It is absolutely necessary to have your work framed. This show is your debut as a professional. You want to sell your art, and people are much more likely to buy it if the pieces are already framed and ready to hang on the wall.

You'll need time to have invitations printed and mailed, and the rest of the exhibit organized. Always give yourself extra time. If you think it will take four weeks to get everything done, give yourself six to eight weeks. There will always be unforeseen complications.

Pick a day and time that will be convenient for you and most of your guests. Generally weekends—Friday or Saturday night or Sunday afternoon—work best. Avoid major national and religious holidays, and major sports events such as the Super Bowl, Olympics or NCAA playoffs.

LOCATION

You don't have to go out and rent a formal gallery space. In many cases a living room, yours or that of a friend, will be fine. In fact, a residential location is often more desirable because both the artist and the guests may feel more at ease. Also, you are starting out with all the conveniences of home, telephone, bathroom, refrigerator and so on. Simply remove any excess furniture, breakable accessories and art that is already on the walls and, voila, you have a gallery space.

Here is a list of requirements to keep in mind when deciding where to have your show. You'll need:

- Enough wall space to hang framed art; enough floor space if you are a sculptor
- Good lighting
- Enough walking-around room for your guests
- Space to set out refreshments
- Convenient parking
- Safe neighborhood
- More than one entrance/exit
- Adequate heating/air

Who to Invite—Your First Mailing List

The mailing list that you create for this first show will be the foundation of your art career. Begin by writing down the names of everyone you think might be interested in seeing your artwork. Start with family and friends. Add church and club members, professional associates, doctor, dentist, insurance agent, auto mechanic and neighbors. Include everyone who has been involved with your art career, teachers, classmates, your framer, photographer and printer. Ask your friends for any people they think would be interested in seeing your art.

KEEP A FILE

If you have a computer, begin a file for your art mailing list. Otherwise, buy a package of 3″×5″ file cards and fill out one card for each name. Record the name, address (including accurate ZIP code), phone number and a short description of each person. Note that you are sending them an invitation to this show and leave room to record any future contacts you have with them regarding exhibits and possible sales.

BUYING MAILING LISTS

There are some existing lists you can purchase. For instance, if you belong to an organization, a church, community or professional organization where people know you, add that list to your own. Special-interest lists can also be useful. For instance, if your paintings are all florals, you might want to mail invitations to members of gardening groups.

However, buying random lists probably won't be useful. It may be possible to get lists of doctors, lawyers or other professionals, lists of museum members, civic groups and so on, but unless these people know you personally, it is not likely that they will come to your show. The money you spend on printing and mailing invitations will be better spent if you restrict your mailing list to people you have some connection with. Also, if the show is in your own home, you might not want to invite absolute strangers.

YOU NEVER KNOW

I'm amazed over and over again at the unexpected people who purchase my art—students with little money, people on fixed incomes, family, other artists. Include everyone possible on your first mailing list.

Invitations

ORDER EXTRA INVITATIONS

During the weeks before your show, carry invitations with you to give to people you meet who might be interested. You'll think of people you forgot in the original mailing, too, so extras will come in handy.

Invitations should be simple, professional and easy to read. You can use a formal invitation or a postcard with a reproduction of your work but, whichever you choose, the following vital information should be included:

- Date, including day of the week, and time of the show
- Location (If the location is difficult to find, include directions or a map.)
- Description of the show (e.g., "You are invited to an exhibit and sale of oil paintings by Carole Katchen. Refreshments will be served." I specify "exhibit *and sale*" so they know this is a professional event, not just a party.)
- RSVP and phone number

THE FORMAL INVITATION

The formal invitation is a card or folded paper, like a wedding invitation. It is professionally printed and clearly states all the information about the show. This style may be less expensive than a postcard with a reproduction, and if it is mailed in an envelope and hand-addressed it makes the recipient feel that she is personally invited to a party.

POSTCARD INVITATION

The postcard invitation has a reproduction of a piece of your art on one side and the written invitation and space for an address on the other. A postcard, even in full color, can be less expensive than you think. Look in the back of art magazines for printing companies who print art postcards at low prices.

You should also get estimates from local printers. Sometimes it is worth spending more money for a local printer so you can supervise each stage of the process. Whatever printer you choose, insist on approving a color proof before the final printing. This reproduction tells people what your art looks like; be sure that the reproduction is reasonably accurate.

One advantage of the postcard is that you can get extra copies so you'll have an example of your work to hand out in the future. For a small extra price, you can usually order some copies of the postcard with the art and the invitation to the show and others with just the art, your name and the title of the work.

I don't recommend a postcard without a reproduction. A plain postcard with just text looks too much like the junk mail people find in their mailboxes. They might not even read it.

WORKING WITH THE PRINTER

Choose an established professional printer to print your invitations. Get bids from several so that you can compare quality and prices.

Get your agreement in writing. In fact, get everything in writing—the number of invitations, size, kind of paper, the date you will see proofs, the date the invitations will be completed and the price. If it is all in writing, there is less possibility of confusion and mistakes; if there are mistakes, the printer will be responsible for rectifying them.

Go over the proofs carefully. Have more than one person check all the information for accuracy—date, time and location. Use the chart on the next page to help you keep track of information when comparing printers.

PRICE COMPARISON CHART

PRINTER	#OF INVITATIONS	SIZE/WEIGHT OF PAPER	TYPESETTING	REPRODUCTION	COLOR	PROOFS DATE	FINISH DATE	PRICE

Always send your invitations by first class mail. Bulk mailings may be cheaper, but the mail takes much longer and often gets lost. You don't want people to receive invitations after the reception.

PERSONALIZE THE INVITATION

Whenever possible, hand-address the invitations and write a short personal note such as "I'm looking forward to seeing you," on every one.

You should also contact everyone personally. The ideal approach is to tell them on the phone that they will be receiving an invitation to this show and you hope they can make it. After the invitations are mailed, call to ask if they have received it and if they'll be able to come. People are more likely to show up if you ask them personally and send an invitation.

Don't be shy about letting people know that you want them to come and see your art. People are generally flattered that you care about them and want to share your art with them. Tell them that this is your first show. This is a special event. If you let them know you are excited about it, they will be too. People like to feel that they are participating in an artist's career. For some of them it is the closest they will ever get to creativity in their own lives.

ADDRESSING AND MAILING INVITATIONS

When planning your schedule, allow several days for addressing invitations. Computerized mailing labels are easiest, but I always think that hand-addressed mail gets more attention. This is a situation where your support crew can help. Once, when I had to do a large mailing for a show, I invited several of my friends over for an "addressing party." After they addressed and stamped the invitations, I provided pizza and wine.

Mail the invitations so that they will arrive ten days to two weeks before the show. It's important to give people enough time to arrange their schedules so that they will be able to attend. Don't send the invitations so they arrive more than two weeks before the show. If they arrive too early, people might forget the show.

Hang the Art

Allow at least one full day to arrange and hang the art for your show. Plan this one day ahead of the show—never the day of the show. If possible, hang the show several days ahead so you have time to look at it and decide if you like the placement of the art. Arrange to have help; it is much easier and safer to measure, lift and hang art when you have at least one helper.

SHOW IT OFF

Some artists draw a diagram of the space and mark where each painting or sculpture will go, but I like to place the actual paintings against the walls so I get a better sense of how the sizes, colors and subjects fit together. Do whichever works better for you, but definitely spend time planning the arrangement before you start hammering nails.

Hang the art with the center of the painting at the eye level of the average person, approximately 60″ from the floor. I hang my paintings so the centers make a straight line around the room. I hang small pieces in clusters, with the center of the grouping at the same height as the centers of the other paintings. Some people hang paintings so all of the bottom edges or top edges are at the same level. This is simply a matter of taste, but do take the time to measure so each painting is in line with the others. This will give the room a well-designed look.

Allow space (at least 12″) between paintings or clusters of paintings. Within a group of small pieces, the space between can be just a few inches. Don't hang paintings in hard-to-see locations such as behind plants, tall furniture or doors. Don't hang art in dark spots where the work can't be seen.

PLACING SCULPTURE

Set small pieces on tables or pedestals high enough for the viewer to see them easily. Be sure pedestals are stable and will *not tip over*. Wherever possible, allow access to the sculptures from all directions so the pieces can be seen from all angles. Leave space between sculptures so each work can be seen separately and guests can walk easily through the room.

LABEL THE ART

Identify each piece of art by title, size, medium and price. I type a label for each painting and attach it to the wall next to the art; some artists put numbers next to the paintings and provide a numbered price list.

I recommend individual labels. Seeing the price is a constant reminder that the work is for sale. Also, it's easier than hunting through a list. Make things as easy as possible for the buyer.

For some artists the hardest part of the whole show is titling the piece of art. The title should distinguish each piece of art.

The Reception

WHAT TO DRINK

Wine has been traditional at art openings, but it's not necessary. Some alternatives to wine are sparkling cider, punch, soda, sparkling water and spring water. If you do serve wine, also have a non-alcoholic alternative for folks who don't drink alcohol.

An art reception is like any other party; you want people to feel welcome in your home or studio. Imagine yourself as a guest at this event and think of what would make you feel comfortable.

The small details are very important. For instance:

- Have someone at the door to welcome guests.
- In case of bad weather, provide a place to store coats and umbrellas.
- Put a small sign on the door of the bathroom so that people can find it easily.
- Provide some chairs for people who cannot stand for long periods.

REFRESHMENTS

Refreshments are not essential, but when people have something to eat and drink, they tend to stay around longer. The longer they stay and look at your art, the more likely they are to buy it.

Refreshments can be as elaborate as hot hors d'oeuvres or as simple as popcorn and pretzels. Don't plan to serve anything you have to prepare the day of the show. I have often served a selection of cookies: Cookies are pretty, can be prepared ahead and are something friends are usually willing to help you provide.

Do not try to serve the refreshments yourself. Your job at the show is talking to people about your art, not setting out cookies and wiping up spilled drinks.

Have plenty of helpers, organized ahead of time. The ideal situation is to hire professional caterers so that you don't have to think about refreshments during the show. If this isn't possible, enlist the help of *reliable* friends. There should be enough helpers to set out the refreshments, to serve drinks and to clean up used dishes and glasses during and after the show. Be sure that everyone knows their responsibilities ahead of time.

REFRESHMENTS CHECKLIST

- Food. List the items on your menu.
- Drinks. List the items on your menu.
- A sturdy table for the refreshments; tablecloth optional.
- A cooler or refrigerator for cold drinks and perishable food.
- A container for ice for soft drinks.
- A coffeepot.
- A teapot, or pitcher for hot water, and tea bags.
- Cream, sugar and lemon (for tea).
- Napkins.
- Disposable plates and cutlery.
- Disposable cups and glasses for hot and cold drinks.
- Serving dishes and trays.
- Trash cans and trash bags for cleanup.
- A responsible helper to supervise refreshments.
- Helpers for serving and cleanup.
- Fresh flowers (optional).

Sales

Everyone gets nervous before a show. Even seasoned professionals worry that no one will buy their work. An advantage of having your own show is that most of the guests will be people who know and like you. They want to support you. Many of them will come ready to buy your art. Your job is simply to make it as easy for them as possible.

BE PROFESSIONAL

It's now that you must separate yourself emotionally from your art. Once the art is done, it becomes a product to sell. There are people who want to buy this product—your art. Your job is to find them, make the work available to them and help them complete the purchase.

Your art reflects your most personal expression. How can you help but feel that it's part of you for sale? Being a professional means that even though you feel this connection to the art, you still act objective about the work. You might feel nervous, anxious, even desperate to sell something, but you must act calm and confident. I promise you: It does get easier with time.

TALK ABOUT YOUR ART

Even before you plan an exhibit, be sure you can talk about your art. It's *very* important.

When you meet someone new, he will probably pay attention to you for thirty seconds just out of politeness. So you have thirty seconds to make that person interested in your art. This exercise teaches you to speak effectively about your art in thirty seconds.

Get a kitchen timer and a tape recorder. Turn on the recorder. Set the timer to thirty seconds and start to describe your art; when the timer rings, stop talking. Play back the recording, listening as if you were a stranger. Repeat this exercise until you're comfortable and effectively describing yourself and your art in thirty seconds. You should sound confident, unhurried (thirty seconds is really quite a long time) and interesting. If you can't judge yourself, ask a friend to listen to the tape with you.

TALK TO YOUR GUESTS

You want to be friendly and hospitable, but you also want to encourage your guests to buy art. How can you be a salesperson without sounding like you are selling?

Viewers often feel awkward talking about art, especially with the artist. They're afraid of sounding unknowledgable or of offending the artist. It's your job to make them feel comfortable.

Talk about the art. Before the reception, practice, practice, practice the exercise above. What makes your art interesting? Unusual techniques? Intriguing subject matter? Exciting colors? Tell them things like: "I found the flowers in that painting down the street in Ann's garden." "Do you recognize the park in that painting?"

Provide art in a variety of sizes and prices, if possible. If someone doesn't have the space or budget for a large piece, there will be something they can purchase. If you do works on paper provide a bin of smaller pieces, matted and covered with acetate, in addition to the framed work on the walls.

SALES STAFF

Help with your show is essential. The ideal crew includes:

One person to greet people at the door. This person should be warm and friendly; her job is to make people feel comfortable about attending the show. She should also invite visitors to sign the guest book. Record the name and address of everyone who attends the show so you can invite them to future events.

Two or more helpers to circulate among the guests. These people answer questions about the art, answer the phone, bring guests to meet the artist and guide purchasers to the sales table.

One or more people to handle sales. These people write receipts, collect money and wrap the purchased art.

Your sales crew should be friendly, courteous and professional. They should constantly watch the guests to see if they need assistance. However, your helpers shouldn't pressure guests to buy. Your guests are, after all, guests. They've been invited to view the art; strong-arm sales tactics are not appropriate. Before the show, take the time to tell your sales helpers exactly what you expect from them.

If a guest decides to buy a piece, refer him to one of your sales helpers. For instance, "If you'd like to buy that piece, Marcie can help you. She's sitting at the table in the corner." Don't write up sales yourself: It's more important for you to circulate among the guests.

When a piece sells, place a red dot on the label next to it to indicate it is no longer available.

BARGAINING OVER PRICES

I suggest not giving discounts. You've already made prices extremely low, and giving discounts is unfair to people who have paid full price. The exception is when a buyer purchases more than one piece; you might want to give a discount. If someone doesn't have the money to pay, suggest that she give you a deposit now and pay the rest over time. Keep the art in your possession until she has paid in full.

SALES MATERIALS CHECKLIST

- List of all the artwork, including prices. If you are charging sales tax, include the tax amounts on the master list.
- Receipt book. Each receipt should contain the title, size and price of the art, and the name, address and phone number of the buyer. A copy of the receipt should be made for the artist's records.
- Pens.
- Cashbox and change.
- Name tags for sales assistants.
- Wrapping paper and tape.
- Sales table.
- Adhesive red dots.
- Guest book.

SALES RECEIPT

ARTIST'S NAME
ADDRESS, PHONE NO.

PURCHASER: _____
(name)

(address)

(phone)

DATE: _____

ARTWORK:

Title	Medium	Size	Price
_____	_____	_____	_____

Subtotal _____

_____% Sales Tax _____

Total Due _____

The artist guarantees that the listed artwork is genuine and original. Reproduction rights are reserved by the artist.

SALES RECEIPT (TIME PAYMENTS)

ARTIST'S NAME

ADDRESS, PHONE NO.

PURCHASER: _____

(name)

(address)

(phone)

DATE: _____

ARTWORK:

Title	Medium	Size	Price
_____	_____	_____	_____
		Subtotal	_____
		_____% Sales Tax	_____
		Total Due	_____
		Less Deposit	_____
		Balance Due	_____

SCHEDULE OF PAYMENTS:

	Amount	Date dute
First payment	_____	_____
Second payment	_____	_____
Third payment	_____	_____
Fourth payment	_____	_____

The artist guarantees that the listed artwork is genuine and original. Reproduction rights are reserved by the artist. Art will remain in the possession of the artist until payment is completed.

SCHEDULE FOR SHOW PREPARATION

The key to a successful, enjoyable show is organization. Schedule all the tasks that need to be completed before the show and then check them off as they are done. It is much too hard to keep everything organized in your head; always put things down on paper (or in a computer).

Besides this list, you should also write on a calendar everything that needs to be done. If you have space on a wall in your studio, hang a large calendar on which you can cross things out as you accomplish them.

DATE DUE		CHECK WHEN COMPLETED
_____	Finish art	_____
_____	Set date	_____
_____	Choose location	_____
_____	Order frames from framer or order framing supplies	_____
_____	Compile mailing list	_____
_____	Order invitations	_____
_____	Research sales tax/get sales tax license	_____
_____	Check invitation proofs	_____
_____	Pick up invitations	_____
_____	Address invitations	_____
_____	Mail invitations	_____
_____	Check on progress of frames	_____
_____	Plan refreshments menu	_____
_____	Order refreshments/start preparing freezable refreshments	_____
_____	Buy supplies for hanging art	_____
_____	Buy supplies for selling art	_____
_____	Clean/organize exhibit space	_____
_____	Recruit helper(s) to hang art	_____
_____	Recruit helpers for refreshments	_____
_____	Recruit helpers for sales	_____
_____	Pick up framed art	_____
_____	Prepare title labels and lists	_____
_____	Hang art	_____
_____	Meet with volunteers to explain their assignments	_____
_____	Set up sales table	_____
_____	Pick up refreshments and supplies	_____
_____	Set up refreshments table	_____

Celebrate Your First Show

One of the most important moments of your first exhibit should happen after it is all over—congratulate yourself for taking such a big step in your professional art career! It doesn't matter whether you sold anything. It doesn't matter whether anybody showed up to view the art. The important thing is that you had the courage to go forward with your dream of being an artist.

Throughout your art career you must continue to acknowledge yourself for proceeding. The success of an artist comes from simply being an artist. Your sales will go up and down. People will applaud you and ignore you. The only thing that remains constant is the process of being an artist. No matter what happens, a professional artist keeps on being an artist. That's where your joy is. That's where your satisfaction is—in creating art.

ASSESS THE SHOW

There are two questions to ask about the exhibit now that it is over:

- What went well?
- What could have been improved?

It is important to assess the show as a professional exhibit, not just as a party. Your obvious goal was to present your art to the public. How many people found out about your art from receiving invitations? How many people came to the show? Did they look at the art? Did they buy the art?

In addition, take a critical look at your presentation. Did the work look professional? Did the exhibit look professional? The hanging? The labeling? Did you have a sales structure that was businesslike?

Finally, think about how you felt and acted during the show. What did you enjoy most about the show? Did you talk to people about your art? Did you act like a professional?

Use this show to find your strong points and your weaknesses. Do not ask if it was a success: It was a success just because you did it!

WHAT DO YOU DO NEXT?

There is a natural letdown once your show is over. You focused intently on only one thing—the exhibit. You worked hard. You were excited, scared, nervous and joyous. And it's all over. Now what?

You could have another home/studio show, using all you learned from the first one to hold an exhibit that is smoother, more fun and more profitable. Or you can explore another kind of exhibit—a group show, a juried show or an art festival, all described in future chapters. The important thing is to keep up your momentum.

There is a tendency to stop and rest when you have reached a goal. Don't. Use what you have already accomplished as a spring board to propel you to the next level.

The best way to get your art to the public is through your own exhibit. Planning is the key to a successful, enjoyable show of your own.

PRE-SHOW PREPARATIONS INCLUDE
- Choosing the date and location
- Finishing all art and framing
- Printing and mailing invitations
- Preparing refreshments
- Hanging or placing art
- Recruiting friends to help with sales and refreshments

AT THE RECEPTION
- Make your guests feel comfortable.
- Be professional. Separate yourself emotionally from your art.
- Talk to your guests about your art. Be gracious and circulate.
- Do not serve refreshments or write up sales yourself.

AFTER THE SHOW
- Celebrate! Congratulate yourself for accomplishing this huge step in your art career.
- Assess the show. Thoughtfully go over what went well and what could have been improved.
- Don't stop now. Decide what avenue you want to take as the next step in your art career.

The Tools You Need to Start Selling Your Art

Selling your art will be easier if you have the business tools you need. These tools include your mailing list, business cards, stationery, brochures, photos and slides, a résumé or career summary and a portfolio.

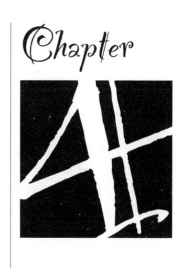

Your Mailing List

FOLLOW UP

Any interested viewer is a possible collector. Whenever anyone expresses interest in your art, follow up. Don't wait for a formal exhibit.

Send a copy of your brochure. Call and invite them to visit your home or studio. Keep people thinking about your art.

The backbone of your art career is your mailing list, the same list you created for your very first exhibit. As your career progresses, add the name of every new person who expresses interest in your art.

WHERE TO FIND THESE CONTACTS

Anywhere and everywhere. Networking is helpful in any business; in the art business it is essential.

At parties, at galleries and museums, in classes, at club meetings, on the golf course, in the grocery store—whenever you meet new people, let them know you are an artist. If they express any interest in seeing your art, add them to your list. Whenever you participate in a public exhibit, provide an address list where people can register for your mailing list.

Ask friends and other contacts in the art world for introductions to people they think might be interested in your art. Go back to chapter three, "Sell Your Art at a Home or Studio Show," and review the points about your first mailing list.

KEEP YOUR LIST UPDATED

Keep the information in your mailing list accurate. People change their names and addresses. They get married. They get divorced. They move. Keep the names and addresses current.

USE YOUR MAILING LIST EFFECTIVELY

One of the most effective tools for building an art career is personal contact. The more that people hear about you and your art career, the more successful and important they will think you are. Use your mailing list.

Here are some possible items to mail to the people on your list:

- Invitations to exhibits
- Announcements of awards and other honors
- Announcements of acceptance into juried shows
- Notification of a new collection of work, a new subject or medium
- Season's greetings cards
- New brochures
- Copies of articles about you or your art
- Announcements of classes or workshops you are teaching
- Notification of interesting painting trips
- Newsletters about your career
- Notices of available cards, prints, posters or books

Newsletters

Many artists send out newsletters on a regular, or occasional, basis. Especially since desktop publishing has become so widely available, the newsletter format is a popular way to send information to a large list of interested readers.

Judy Treman, a successful watercolorist in Washington, sends out what she calls a *Studio Report*. Treman sells all her art directly to collectors, either through the mail or in person; she doesn't use galleries at all. She explains, "I don't do a lot of paintings in a year and I was selling enough that I thought I didn't really need galleries. Of course, when you don't work with galleries, you have to work harder."

Treman has collectors all over the country, and it takes effort to remain in contact with all of them. That's why the newsletter is so valuable. Her mailing list contains 1,200 names of people who are interested in her art. Where does she get the names? Some are from personal contact; others are taken from the guest list of shows like the exhibit she had at the Fry Museum in Seattle.

She says that not all of the people on her list have bought her art yet, but she knows that the better acquainted they become with her and her work, the more likely they are to purchase. She offers low-cost greeting cards and posters for beginning buyers.

Treman's letter comes out "often enough that they won't forget me," but not on a regular basis. The most recent was three pages in black ink on cream-colored paper. It was well designed and professionally printed. Every page contained her address and phone numbers, including a toll-free 800 number.

Page 1 contained a short letter from the artist; a description of new watercolors; an ad for cards, posters and prints; announcements of her work in books and magazines; and an announcement of an upcoming workshop she is teaching. Page 2 was devoted to reproductions and information about posters, cards and prints available for sale. Page 3 contained an order form, plus the following list to be returned to the artist:

Please check appropriate items:

☐ Please send me future studio reports.
☐ I would like a studio visit.
☐ I am interested in original watercolors.
☐ I am interested in limited-edition prints.
☐ Please add a friend to your mailing list. (space for name and address)
☐ Delete me from your mailing list.
☐ Change of address.

DRESS FOR SUCCESS
There is no standard uniform for an artist. My advice is to express your creativity in your art— let your clothing make a statement of quiet, confident success.

Business Cards and Stationery

KEEP IT SIMPLE

A business card is just that—for business. You will be tempted to design a card that is "artistic"; it's purpose, however, is simply to tell people how to find you in order to buy your art. Keep it simple. Keep it direct. Keep it businesslike.

BUSINESS CARDS

Like all professionals, you can use printed materials to support your image. Business cards are a must. Your business card should contain:

- your name
- a brief description (such as artist, sculptor, watercolors or stained-glass artist)
- phone number
- address

Keep the design and type style simple. The most important aspect of a card is that it is easy to read. Some artists include a hand-written signature on the card to make it look more interesting; if you decide to do this, also show your name printed so that there isn't confusion about your name or how it's spelled. If you use color card stock or color ink, choose colors that are easy to read.

Some artists include a small reproduction of their work, but I discourage that for beginning artists. At this point in your career your art is still changing; a reproduction you choose today might not represent your work in the future.

Keep a supply of business cards with you at all times. Whenever anyone expresses interest in your art, give him your card. Besides giving people a way to contact you if they want to see your work, just seeing your name in print will make it easier for them to remember you.

STATIONERY

Sending letters on professional-looking stationery will help to convince people you are an established artist. Again, the design should be simple and easy to read. Use a substantial paper, one with more weight than basic photocopy paper. People might not consciously notice the weight of the paper, but it makes an unconscious impression. A substantial paper suggests a substantial career.

Do not use bright or dark colors of paper for your stationery; white, off-white or very light colors work best. If you want to show originality in the paper, choose paper with an interesting texture—but again, keep it subtle. The color of the ink should be dark enough to read easily. Avoid fluorescent colors.

The most important things to have on the stationery are your name, address and phone number. These should be prominent and easy to read.

As with business cards, it is generally better not to use a reproduction of your art on your stationery until you are far enough along in your career to know that your work will remain consistent.

If you decide to use a reproduction, be sure it is an excellent one. People will think that your art looks exactly like the image on your stationery. If the image is pale or out of focus, they will think that's how you paint—they won't realize that the photography or printing was bad.

A Picture Is Worth a Thousand Words

Another tool to help you sell your art as a professional artist is photos. Photograph every piece of your art that is good enough to exhibit.

COLOR SLIDES

Take slides—professional-quality slides—for entering shows, for keeping records of your art and to include in publicity. Use slides rather than color prints; color reproductions in magazines and other printed materials are done from slides.

I often hear artists say, "I can't afford good photography." Believe me: *You cannot afford bad photography!*

Good photo images are important because often they are all that people ever see of your work. If you send bad slides to juried shows, galleries or magazines, they will either think that your art is bad, because it looks that way in the slides, or they will think that you are not a serious professional.

Unless you are an experienced photographer or you are willing to take the time and effort to become an excellent photographer, you should hire a professional to shoot your photos. It doesn't cost any more to hire a professional photographer for an hour than it does to shoot several rolls of film yourself trying to get one decent slide.

If you really can't afford to have excellent slides taken of *all* your work,

choose the best of your artwork to photograph rather than taking poor slides of all of it. (I include a description of good slides in chapter five.)

As an art writer, I have noticed how artists with good photography get much more attention in the media. When I am looking for artists to include in a book or magazine article, I always choose good slides over mediocre slides. Even if the art is the same quality, I know that the good slides will always look better in publication.

BLACK AND WHITE

Black-and-white reproductions are made from black-and-white photos. It's good to have black-and-white photos of yourself and your art on hand for publicity in newspapers; they should be sharp, clear and of high contrast (that is, ranging from deep black to pure white). Photos without much contrast will reproduce as dull gray in newspapers.

COLOR PRINTS

There are some uses for color prints of your work; they can be useful in showing your art to interested collectors or dealers, for example. However, the color prints must be of excellent quality, and generally 5″ × 7″ or larger. Small, casual snapshots of your art may make viewers think of you as an amateur.

It's Your Call

Your Career Summary

*Success
Story*

At the beginning of your career you probably won't have enough credentials to create an impressive résumé. Don't worry about it. I suggest you start with a career summary instead. This is a short paragraph or two that describes your background, education, work experience, interest in art and anything else that is both interesting and relevant to your art.

IT TELLS ABOUT YOU

Your career summary introduces you to the art world: It should tell that world about you as an artist. After reading it, people should have no doubt that you are a committed artist.

Write down everything you can think of about yourself that might relate to your art in any way. Then go through the list and pick out those things that make you sound like a professional.

You don't need to say a lot about yourself. In fact, it is generally better to keep statements about yourself brief. Most people won't take the time to read anything long. All you need are a few sentences that will give the reader a sense of who you are as an artist. Collectors want to relate to the artist as a person. They want to feel like they know you. The career summary helps them do that.

Your career summary should be printed in easy-to-read type on a good piece of paper. You can use your letterhead, or plain paper with a contact phone number and address at the bottom. Be sure that it always gives the reader a way to contact you. The printed career summary can be given to anyone who is interested in your art. Have plenty of copies available at exhibits and in your studio. Whenever you send a package of material about yourself, include a copy of your career summary.

AN ARTIST'S STATEMENT

An Artist's Statement consists of a few sentences that tell why the artist creates his art. It can be part of the career summary or a separate sheet. Be sincere and thoughtful. Don't use a lot of big words or literary phrases; just speak in a way that non-artists can understand and tell why you create art. It might help to use a tape recorder. Speak into the recorder, describing why you are an artist and why you create this particular art. When what you've recorded sounds honest and understandable, write those words down and use them as the basis of your Artist's Statement.

It is not necessary to have an Artist's Statement. If you don't have strong feelings about why you create art—or if you don't know why you create art—don't make something up. Wait. An insincere Artist's Statement is worse than no statement at all.

A FICTITIOUS CAREER SUMMARY

Mary Johnson, 56, of Hot Springs, Arkansas, has only been painting for two years, although she took a few art classes at the University of Arkansas in Little Rock in her youth. More recently she has attended adult education classes in art and watercolor workshops from local artists. She prefers to paint flowers, especially local wildflowers. Her hobbies are sewing and gardening. She has been a member of the Ouachita Horticultural Society for twenty-five years.

Her Career Summary:

Mary Johnson, an expert on plants and flowers of Central Arkansas, paints watercolors of local wildflowers. She has been a member of the Ouachita Horticultural Society for twenty-five years. She studied art at the University of Arkansas in Little Rock and at other schools in the area.

WHY YOU CREATE ART

What if you can't think of anything? You are not a gardener. You have never studied at a university. You don't have anything else that sounds like a credential to you. Then ask yourself why you create art—that is interesting to most people. Or ask yourself what it is that you find most exciting about creating art. For example:

Paul Rodgers is a sculptor because he is fascinated with clay. He likes to take a shapeless part of the Earth and turn it into objects that people can recognize. His studio is in Loveland, Colorado.

Martha Wallis started drawing as a young child. She has always been interested in human faces, and that is what she captures in her pen-and-ink drawings. She is a native of Dallas, Texas.

AN ARTIST'S STATEMENT IS IMPORTANT

Carolyn Taylor of Taylor's Contemporanea Fine Art Gallery in Hot Springs, Arkansas says, "I want to get a sense of the artist and if she is serious. I want to see a consistent effort in her art career. An Artist's Statement is important. It should say what the artist is thinking."

EXERCISE:
WRITING A CAREER SUMMARY

One reason it's hard to write about ourselves is that we have trouble being objective. One way to increase your objectivity is to put all the information down in black and white.

Sit down with a blank pad of paper and a pen and jot down everything you can think of about your personal history. As you answer these questions, you will begin to get a more objective view of yourself.

- Where and when were you born?
- Where did you go to school?
- What were your interests as a child?
- Did you go to college? Where?
- What did you study?
- Are you married?
- Do you have kids?
- Where do you live now?
- Have you had a non-art career? Doing what?
- Have you received any public recognition from your career?
- Where have you traveled?
- What are your hobbies and other interests?
- What organizations have you belonged to?
- Have you received any community recognition? For what?
- What have you studied as an adult?

Now write down everything about your interest in art.

- When did you first start to draw (paint, sculpt)?
- Was your family interested in art?
- Were there any artists in your family?
- Did you take art classes as a child?
- Did you study art in school?
- Did you attend an art school?
- Did you take any art classes or workshops?
- Did you study with any well-known artists?
- What made you decide to become an artist?
- When did you decide?
- Have you ever exhibited your art? Where? When?
- Have you sold any art?
- Have you won any awards as an artist?
- Have you gotten any other public recognition as an artist?

Now take a colored marker and highlight any facts that seem relevant to your art career. Copy those on a separate piece of paper. Look for the most interesting and relevant details and use those facts as the basis for your career summary.

Résumés

Résumés are more formal and require specific credentials. You don't need a formal résumé until you are farther along in your career. However, it is good to know what goes into a résumé so that you can be working in that direction.

An artist's résumé generally includes education, solo exhibits, group exhibits, publications, awards and inclusion in public and corporate collections.

THE BEST CREDENTIALS

Some art experiences make better credentials than others. For instance, exhibits in public spaces carry more importance as credentials than private exhibits. An exhibit in a private home or studio is a wonderful experience and will definitely enhance your career, but it should not be listed on a résumé.

The best exhibits to list are those in major galleries or museums. National juried shows are also excellent. Education in universities or recognized art schools is a good credential; workshops with unknown teachers are not. Any kind of award or publication about your art is good, but the best are national or international.

At first, the whole issue of résumés and national credentials may seem impossible. Don't worry about that now. First concentrate on local exposure for your art. As you continue with your career, you can gradually reach out for wider acceptance. Start by entering regional and national juried shows. If you lack formal education, improve your credentials by taking classes at a college or art school.

KEEP YOUR RÉSUMÉ CURRENT

As you continue with your career, you will acquire more impressive credits. Be sure to upgrade your résumé, replacing local shows and education with national awards, solo gallery shows, corporate collections and museum exhibits.

Brochures

TIPS ON WRITING BROCHURES

- Keep the writing brief.
- Don't use flowery or intellectual language.
- Write only what is most interesting.
- Tell the truth. (Don't exaggerate or make up credentials.)
- Write for non-artists.
- Write about successes, not negatives.
- Always include a contact number.

A printed brochure provides a quick and impressive presentation of your art. It can be a very simple black-and-white page including a reproduction of one piece of art and your career summary, or a more elaborate folder printed in color with several pieces of art and your career summary.

THE DESIGN

Keep the design simple. Leave empty space for margins so the work doesn't appear crowded. Make your art reproduction(s) big so that they are easy to see. It's better to reproduce one image large than several images too small to see well. Collect other artists' brochures or ask to see a printer's samples to help you decide on a design.

ART REPRODUCTION

The most important component of a brochure is the artwork. The art must be reproduced beautifully. If money is limited, use black-and-white printing. Pick a few pieces of art (even if you are only using one photo) that have good contrast. Have a good photographer photograph them in black and white, and then choose the best print. Sometimes the best painting will not make the best photograph. Pick one that's sharp, interesting and has good contrast. It helps to ask several people which photo appeals to them.

If the brochure is color, it's even more important to have excellent pho-tographs because the color must be accurate. Have a professional photographer shoot color transparencies of a few favorite pieces. Again, ask several people which image they like best before you make your choice for the brochure.

With sculpture you might use more than one photo to show a piece of work from different angles. Be sure that it is well-lighted and has a simple background, so the sculpture itself is visible.

THE TEXT

Keep the text brief. You can use your career summary or part of your career summary. Don't give people too much to read. The text should take up less room than the reproductions.

Be sure that the brochure gives a contact phone number and/or address. This is very important. People might take the brochure now, look at it sometime in the future and decide to contact you then. Make it as easy as possible for them to do that.

THE PRINTER

Once you have excellent photos and the text, you can select a printer. Use the same procedure you used in choosing a printer for invitations (see chapter three). Insist on seeing examples of the printer's previous work, especially brochures that are similar to what you want. Do not accept any printing job that does not show your art well.

Portfolios

A final tool for selling your art as a professional is a portfolio. A portfolio isn't necessary when you are beginning; in the early stages of your career you can use a career summary and one sheet of good slides. However, as you acquire invitations to your public exhibits, brochures, newspaper reviews and other evidence of your professionalism, you should present all of those items in a portfolio.

A portfolio is not a scrapbook for snapshots and torn-out clippings: It is a professional presentation. Everything in it should look professional.

FORMAT

The best format for a portfolio is generally a large loose-leaf binder with acetate pages. Reproductions and information about your art and career should be neatly arranged and mounted, so that the portfolio tells the reader everything they need to know about your art even if you are not there to explain it.

WHAT GOES INTO THE PORTFOLIO?

On the cover or first page your name should be printed prominently so the reader immediately knows whose work this is. Include a copy of your career summary or résumé; an Artist's Statement; a copy of any brochures of your work; copies of announcements or invitations to public exhibits, especially those that show reproductions of your work; any printed publicity about your art, such as newspaper articles, reviews and prominent advertisements; and photos of some of your better pieces.

REPRODUCTIONS

Invest in at least a few professional 8″ × 10″ photos of your better pieces. Do not use snapshots. I have found that high-quality color photocopies made from excellent slides can make a good impression. Remember: The images must be sharp and the color accurate. I must again stress the quality of your reproductions: Showing people bad reproductions of your art can be worse than not showing any.

Each piece of art should be labeled with title, medium and size.

You might also include a good photo or two of you working in your studio or on location.

Arrange each page so that it is neat and easy to look at. The portfolio does not have to be thick; just a few pages will be enough to give an impression of your work. This is not a sentimental memory book, but another tool to show that you are a successful professional artist.

A GUIDE FOR PORTFOLIO ASSEMBLY

- On the first page—a large color photo of one of your best, most recent pieces of art, mounted below your name. Readers will immediately see your name and your art; this will be their first impression. Your address and phone number should be visible either on the cover or first page.

- Several pages containing show invitations, newspaper clippings about your art, an Artist's Statement, brochures and other publicity. If you don't have any printed publicity, include four to ten excellent 8″ × 10″ photos of your art, followed by a career summary. Be sure you have a reproduction of your art on at least every other page. If you don't have printed reproductions, include large photos (professional quality) or *excellent* photocopies.

- Toward the end of the book—a large, professional-quality photo of you working in your studio or on location. This should be a picture that shows that you are a professional artist.

- Close the portfolio with a copy of your complete résumé or career summary.

Neatly arrange and mount the material in acetate-covered pages. Bind the pages in a loose-leaf folder with a leather or heavy cardboard cover. I recommend a black or other simple cover and black pages.

You need business tools to sell your art. These tools include:

MAILING LIST
- The backbone of your art career. Add the name of every person who shows interest in your art to your list.
- Keep your list current.
- Use the list effectively.
- Many artists mail newsletters to the people on their mailing list.

BUSINESS CARDS AND STATIONERY
- Keep the design and type simple.
- Your style may change; so don't include a reproduction early in your career.
- Always include your name, address and phone number.

PHOTOS AND SLIDES
- Professional-quality color slides of your work are a must.
- Black-and-white photos of you and your art are good to have for newspapers.

CAREER SUMMARY AND ARTIST'S STATEMENT
- Your career summary introduces you to the art world and gives the reader a sense of who you are as an artist.
- Keep it brief and interesting.
- An Artist's Statement consists of a few sentences that tell why an artist creates his art.

RÉSUMÉS
- Résumés require specific credentials, which include education, public exhibits, publicity, awards and inclusion in major collections.
- You don't need a formal résumé until you are further along in your career.

BROCHURES
- A printed brochure provides a quick and impressive presentation of your art.
- Your art is the most important component: It must be reproduced beautifully.
- Keep text brief.
- Include your phone number and address.

PORTFOLIOS
- A portfolio shows your professionalism.
- It is not a scrapbook.
- Keep it simple.

Sell Your Art at a Group Show

Group shows provide valuable exposure for your work—and can be a lot of fun, too. You share the work, the responsibility and the celebration with fellow artists.

Three opportunities for you to get started selling your art through group shows are the co-op show, the membership show and the juried show.

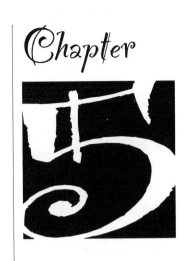

Chapter

5

Co-Op Shows

A co-op show is much like the solo exhibit we examined in chapter three, except a group of artists host the co-op show and all the work is exhibited together.

FIND THE OTHER ARTISTS

The other artists can be friends, or participants in classes or workshops that you take. It doesn't matter if the art for the show is similar or different; it doesn't matter if the other artists have more or less experience. The most important factor in choosing participants for this kind of show is that everyone is willing to work hard for the success of the show.

ORGANIZE THE GROUP

Two things are vital in this type of undertaking: total communication and total cooperation.

After you recruit all the participants, hold a meeting when everyone can be present. At this meeting, lay out the basic structure of the show—where and when it will be held, who will be responsible for what aspects of the show, and how and when you will continue to communicate with each other. Choose one person who will be responsible for coordinating the entire show; his job is to keep track of what is and is not getting done on time.

Everyone should be well informed in each step of the process of organizing the show. Everyone should feel they are part of the decision-making process. Regular meetings are useful. In between meetings, stay in touch by phone.

Be very specific about what tasks each person is responsible for. Divide things evenly. If everyone completes their tasks, the work will be divided fairly and is certain to be accomplished.

MONEY

Everyone should contribute the same amount of money. Develop a tentative budget at your first meeting. Determine the amount of money you will need and divide that amount among the members of the group. In general, it is best to keep everything on a cash basis and divided evenly among members, but there might be occasions when certain participants could more effectively contribute goods or services.

Allow enough money in your budget for a contingency fund to cover unexpected expenses. It is better to have extra money from the beginning than to have to come up with more money later on. Any extra funds can be returned to participants after the show.

LOCATION

You will probably need a larger space for a group show than for a solo show. All the artists in your group should explore the community looking for exhibit sites.

Many public spaces are appropriate for a group art show—consider hospitals, restaurants, banks, offices and lobbies of office buildings, party rooms at apartment complexes, community centers, churches and synagogues, and libraries and schools. Businesses are often delighted to host art shows because it improves public relations; some may even be willing to make a contribution to your exhibit, such as invitations or refreshments. Be sure to explore that possibility.

Owners of unoccupied buildings are often willing to let you use their space until they find a new tenant.

If you select a public or professional space, be sure that you understand all their requirements, such as: available dates and times for hanging the show, for holding the opening reception and for dismantling the show; possible parking; limitations regarding refreshments; acceptable places to display art; and rental fees.

INVITATIONS

Send invitations to each artist's entire mailing list. Every artist's name should be printed on the invitation. When you mail your invitations, highlight your name with a colored marker so that your patrons will know the invitation comes from you. Add a brief hand-written note.

BE CONSIDERATE

Choose one person from your group to coordinate everything with the representative from the location of your exhibit. Always treat the space and the people with consideration and respect.

All artists should help dismantle the show and clean the space after the exhibit. Leave the space exactly as you found it. Be sure to return furniture to its previous position, and to fill in holes in the walls created by picture hangers.

HANG THE ART

There are two ways to hang a group show. One is to display all of the work by each artist in a separate location; the other is to intermingle the work, placing paintings and sculptures near complementary works, regardless of the creator. Either style is acceptable. The choice often depends on the location. In some spaces it is not possible to find separate areas for each artist.

Be sure that all artists' works are well displayed. No art should be displayed in a stairwell or dark corner. A professional display shows respect for every piece that is on exhibit.

SELL THE ART

Even though there will be several artists at the reception, you should still recruit helpers so that all the artists are free to interact with the viewers. Review the section on sales in chapter three. Train your sales staff to keep careful records of what is sold, by whom and for how much. This is essential so there won't be confusion about who is to receive how much money after the show.

With a public show, try to keep the art on exhibit for longer than just the opening reception—as much as a few weeks or a month longer, if possible. You should have someone sitting with the show at all times that it is available to the public. That person should welcome any viewers, answer questions about the art and the artists, and make sales. Your group of artists might want to divide up the time of the exhibit and take turns sitting with the show. It can be very educational for you to sit with your work in a public place. It gives you the opportunity to find out how people respond to art in general and your art in particular.

If you have made your exhibit a charity benefit, be sure to deduct the percentage for charity before disbursing sales money to the artists.

ASSESS THE SHOW

After the show, have a final meeting to discuss what worked and what could have been improved. Every art event should be a learning experience to help you be more effective in the future.

Membership Shows

Earlier I mentioned the value of joining local art societies, leagues or guilds. Besides providing camaraderie with other working artists, most of these clubs arrange non-juried group shows of their members' works. These shows are a wonderful opportunity for the new artist to hang art in public. The shows are hung in hospitals, libraries, restaurants, banks and community centers, as well as in galleries and museums.

For member exhibitions, all artists in the club are usually invited to contribute one to three pieces; the work does not have to pass the evaluation of a jury. So no matter what level your art has reached, it'll still be included in public exhibits, giving you experience and exposure.

Some art societies are listed in the phone book. Also check newspaper and magazine listings and ask other people involved with the arts—artists, art supply salespeople, museums, galleries and framers. Many clubs are open to all artists. Some are restricted by medium or style like watercolor or plein air painting. Some demand that you apply for membership and meet certain requirements before you are granted membership. Check with each group to see what their membership policies are.

TAKE ADVANTAGE OF THE SHOWS

There are several ways to best take advantage of membership shows. First, use them as an incentive for creating new art. One of the biggest impediments to continuing to produce art is the feeling that it is all just stacking up in your studio, and no one is ever going to see it anyway. Membership shows help solve that problem. You are guaranteed an ongoing outlet for your work.

Use the shows to hone your professional skills. Be conscientious about deadlines. Deliver your work on time and appropriately framed or mounted. At the show, notice how other artists' work is presented compared to your own. Are the mats clean and evenly cut? Are the frames well assembled? Are the sculpture mounts stable and appropriate to the sculptures? When your work is on exhibit in a public space, it will be more obvious to you how professional or non-professional your work appears.

Attend every opening reception: Use them as practice sessions for meeting new people and talking with viewers about your art. Get the name and address of anyone who expresses an interest in your work. This is a good way to build up your mailing list.

Finally, volunteer to help with the show. Participate in all aspects of the exhibit: Finding the location, assembling the art, preparing publicity, providing refreshments, hanging art and making sales. All of this experience will help you become a more effective professional. You'll be more comfortable and effective at staging your own home shows, and you'll gain a greater understanding and appreciation of what galleries do.

WORDS OF WARNING
Never get so involved in helping with organizations and exhibits that you no longer have time to produce your own art. Remember: Creating art is what this is all about.

Juried Shows

DO THIS NOW!

Read the competition listings in The Artist's Magazine, American Artist, Art Calendar *and other art magazines. Underline or highlight all the competitions you are eligible for. Write for the prospectus for at least five of these shows.*

The third type of group show to consider is the competitive, or juried, show. They are called "juried" shows because a jury chooses only the best of the art submitted to hang in the exhibit, and therefore the shows are usually more prestigious than the types we've talked about previously. The jury might be one person, or a committee of accomplished artists or other art experts, such as museum curators and art dealers. These shows are sponsored by local and national art organizations, museums, universities, publishers, municipal governments and others.

To enter, each artist submits at least one piece of art or a slide of the art, an application form and often an entry fee. Each piece of art is judged. The art that is accepted is included in the exhibit, and often awards are given to the best of those pieces. The rejected artworks or slides are returned to the artist.

FINDING JURIED SHOWS

Every year there are numerous juried shows all over the country. Art magazine listings are a great resource for finding juried shows. An excellent source is *Art Calendar*, available on newsstands or by writing P.O. Box 199, Upper Fairmount, MD 21867-0199. Contact local and state art councils for additional local competitions.

When you find a competition that looks interesting, write or call for a prospectus. The prospectus gives you information about the requirements for the show and contains an application form. Read the prospectus carefully for information that relates to your art.

DELIVERING THE ART

If you are accepted in a show, you are responsible for delivering your art before the show and picking it up afterwards. For local shows this is usually not too complicated. You simply drop it off and pick it up when they specify. Two-dimensional work must be framed and ready to hang. Sculpture and other three-dimensional art also must be ready to display.

If the show is beyond driving distance, arrangements get a bit more complicated. Prepare your art so that it is ready to display. Add whatever labels the show requires. Then carefully wrap and crate the art for shipping. If your art is under glass, I recommend using a wooden crate and shipping by air. If you don't know how to crate the work yourself, use a box-and-ship store that specializes in shipping packages.

Sometimes the work has to be delivered uncrated on a particular day. In that case the organizers of the exhibit will usually recommend a handling agent to whom you ship your crated work. As long as you get it to the agents on time, they'll deliver it correctly to the show.

The whole process can be an expensive one, but for a beginning artist juried shows provide excellent credentials.

HOW TO READ A PROSPECTUS

Every prospectus includes several crucial elements. When you receive a prospectus, read through the entire brochure. Then read through it again, section by section, making sure you understand every element. I use a yellow marker to indicate specific information, like dates, addresses and fees, I want to remember.

Some of the important elements:

CALENDAR

This list of dates tells when applications are due, when artwork is due, when the show opens and closes, when the opening reception occurs and when artwork is returned. You must be on time; you'll be excluded from the show if you're late.

LOCATIONS

It will tell you where the show will be hung, where to send slides and where to deliver work. Read carefully: These may be three different addresses.

ELIGIBILITY

There are a wide variety of restrictions for shows. Read this section carefully.

APPLICATION PROCEDURE

The prospectus will contain an application form and directions for filling it out. *Read and follow the directions exactly.*

It will also contain information about entry fees. Be sure to enclose a check for the right amount with your application.

SLIDES

If required, the application will tell you how many slides to submit and how to label the slides. *Label the slides exactly as instructed.* Only send professional-quality slides—they must be sharp; they must have accurate color, good contrast and even lighting; and there should be nothing extraneous in the picture.

The prospectus usually asks for a self-addressed stamped envelope to be enclosed for notification of acceptance. Don't forget the envelope.

SHIPPING AND HANDLING

This section tells you where and how art should be delivered. The prospectus may list a handling agent to whom you can ship your artwork. For a fee, they unpack the work and deliver it; then they will pick up, repack and return the art.

JURY

The prospectus usually gives the names of the jurors and lists their qualifications.

SALES AND AWARDS

Most exhibits take a commission from sales: The prospectus tells you how much. It also tells you whether there are cash or other awards for top artwork.

FRAMING

Some shows have specific requirements about frames.

LIABILITY

Usually juried shows accept no responsibility for the safety of artwork during shipping, storage or exhibition. Most damage occurs during shipping. To minimize damage, always mat and frame paintings sturdily. Wrap the artwork in a generous amount of foam or bubble wrap and pack it in a heavy-duty wooden crate. Ship artwork by air if possible.

INFORMATION

There will generally be a contact person listed with a phone number and/or address.

SLIDES ARE IMPORTANT

Slides of professional quality are extremely important. If you can, hire a photographer who is experienced in copying artwork—at the very least buy a book on photographing art.

Slides should:

- be sharp
- reproduce accurate colors—look at them next to your art
- have good exposure—not too dark or light
- have even lighting—no bright spots
- display art square to the frame—no uneven margins
- have nothing in the slide except the artwork

IF YOU'RE NOT ACCEPTED

I suggest that you enter several shows during the year. The more you enter, the better your chances of being accepted in a show. I must caution you that, even after thirty years as a professional artist, I still get rejected from shows. So please understand that not being accepted in some juried shows is all part of the process of becoming a professional.

Even though you read the prospectus carefully, sometimes you still enter a show that is not appropriate for your art. For instance, you might send slides of abstract paintings to a show that wants only traditional art. In addition, the judges for each show are people with their own personal tastes and prejudices; they are influenced by their own taste in art.

If my art is not accepted for a show, I know it just means that this particular judge or group of judges did not like this particular painting I submitted or that the painting was not appropriate for the show. I've even had a painting not accepted at one show and then two months later that very same painting received an award in another show.

It is frustrating when you hear your art isn't accepted in a show, but keep the situation in perspective. Each show you enter is one more step along your path. Know that your career will continue beyond any one show.

ATTEND THE SHOW

Whenever possible, attend the opening reception of the show even if you have not been accepted into the exhibit. This will give you the opportunity to see what kind of work was accepted and compare it to your work. You will also be able to meet the artists whose work was accepted. The more art you view and the more artists you get to know, the more professional you will become.

INCREASE YOUR ODDS

Here are some tips to help you get accepted into juried shows:

- Enter only your very best work.
- Start with small, local shows. If you belong to an art league or guild, begin with their competitions.
- Read the prospectus carefully to be sure that your work is eligible. Underline all of the requirements. Follow the directions.
- Get your entry in on time.
- Fill out the application completely and accurately.
- If the prospectus asks for a self-addressed, stamped envelope (SASE), be sure to include a self-addressed, stamped envelope.
- If entry is by slides, be sure that your slides are of professional quality (see Hot Tip).
- If entry is by actual artwork, be sure that your work is presented professionally. Two-dimensional work should be framed in professional-quality frames, ready to hang. Sculpture should be completely finished and mounted on an appropriate base.
- Label your slides or art work as indicated in the prospectus.
- Enter as many shows as you can afford.

ART CONTESTS

There seem to be more and more contests available for artists. These are competitions sponsored by art magazines, manufacturers of art materials and various other public and private organizations. The entry procedure is very much the same as for juried shows; the difference is that there usually is no formal exhibition of the work. Winning entries are reproduced in publications or as posters. Prizes range from a mention in a magazine to many thousands of dollars.

Although most are legitimate, I caution you about entering any show where the entry fee seems unreasonable high. Some contests are simply a way for the organization to make money at the expense of the artist. Also be cautious about sending original artwork to any gallery or organization you've never heard of—you might never see it again.

TRACKING JURIED SHOWS

It's good to enter as many shows as you can, especially local shows. However, it's easy to get confused about when and where slides and art are due. A simple chart can help keep you organized. It also provides a useful record of your art activities.

Show	Prospectus sent for on	Slides due date	Slides sent	Accepted/ rejected	Art shipped	Art returned
_____	_____	_____	_____	_____	_____	_____
_____	_____	_____	_____	_____	_____	_____
_____	_____	_____	_____	_____	_____	_____
_____	_____	_____	_____	_____	_____	_____
_____	_____	_____	_____	_____	_____	_____
_____	_____	_____	_____	_____	_____	_____
_____	_____	_____	_____	_____	_____	_____
_____	_____	_____	_____	_____	_____	_____
_____	_____	_____	_____	_____	_____	_____
_____	_____	_____	_____	_____	_____	_____
_____	_____	_____	_____	_____	_____	_____
_____	_____	_____	_____	_____	_____	_____
_____	_____	_____	_____	_____	_____	_____

Group shows provide exposure for your art and experience with exhibitions. Three types of group shows are the co-op show, membership show and juried show.

CO-OP SHOW
- These shows are held by a group of artists.
- Communication and cooperation are the keys to a successful, enjoyable co-op show.
- Divide the work and expenses evenly among all the artists.
- Many of the details of the preparation and the reception are similar to the home show.

MEMBERSHIP SHOWS
- Another benefit to joining art societies and guilds is that these organizations usually hold shows for their members' work.
- Volunteer to help with the exhibits, but remember to never become so involved in an organization or show that you don't have time to create art.

JURIED SHOWS
- A jury or committee consisting of accomplished artists or other art experts chooses the art to be exhibited in the "juried" show.
- Enter shows appropriate to your art.
- Follow directions on the prospectus carefully.
- Submit only your best work.

Sell Your Art at Art Fairs and Festivals

Art fairs and festivals can be found throughout the country. These art exhibits, held in parks, on sidewalks and in malls, are a great place to sell your art, especially if you enjoy interacting with the public.

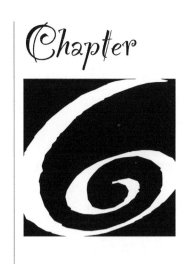

Art Fairs and Festivals

CREATE A SHOW FILE

Accumulate all the information you find on art fairs in a file folder. Cut out magazine listings and save ads from newspapers. If someone mentions visiting a show, make a note of it. Periodically review the file to find shows that you might like to enter.

For most art fairs and festivals you pay an entry fee, bring your own booth for displaying your art and set up in an assigned space. You sit with your exhibit for the duration of the show, answering questions from the spectators and making sales.

Most art fairs and festivals are annual events. If possible, visit a show to see how it's run before you enter it. Talk with some of the exhibiting artists and ask them to share their experience of this show and others they have attended.

RESEARCH THE SHOWS

Find show listings in art magazines. Local shows will be publicized in local newspapers. Talk with people in your art network: the artists, framers, art supply salespeople and others you are getting to know as a professional artist. Also check the newsletters of any art societies you have joined. Write or call for information about shows and request a prospectus.

The prospectus should provide all the information you need to prepare for the show. If you still have questions, call the contact person listed in the prospectus.

Some things to note in the description of an art fair:

- Location. Is it close enough to get there easily from home? If it's not within commuting distance (you are going to have to be there for at least two or three days), are there acceptable hotels in the area?
- Fee. What is the entry fee? Be sure to check if the organizers take a percentage of your sales.
- Juried entry. Do you have to compete to be an exhibitor? What are the guidelines for selecting artists?
- Booth. Do they provide the display booth? If not, are there requirements for the type of booth you must use? How large a booth can you have?
- History of the show. How long has this particular show been in existence? How many visitors attended last year? What were the total sales?

Prepare for the Show

THE ART

Have your art framed and ready in plenty of time for the show. Be sure to include a variety of sizes and prices. It is a good idea to have a selection of matted, but unframed, work that you can sell for lower prices.

YOUR BOOTH

A unique aspect to this type of show is the "display booth." Consider your booth very carefully—it's a sales tool. It should look professional and be arranged to show your art to its best advantage. Put as much thought into the arrangement and display as you would for a home, studio or group show.

Build or order your booth long before the show. You need plenty of time to try it out—and you do need to try it before the fair. Learn how to assemble it. Try different ways of hanging your art on it before you get to the show. The art fair isn't the place to discover that your booth doesn't work.

Premade booths are advertised in art magazines; but any competent carpenter should be able to help you design a booth that will fit your needs and the specifications of the show. Remember that the booth must be sturdy enough to support your art and withstand extreme weather conditions, but also easy to transport and assemble. Take a good look at exhibitors' booths at the shows you attend. Go ahead and ask where they bought or had their booths made. Ask what they would change and what they like about their setup.

Remember to include a comfortable chair (or chairs) and a table (or tables). You will be at the booth for days; make yourself as comfortable as possible. It's also a good idea to bring a cooler with soft drinks and snacks.

Some artists include an easel or worktable in their display so they can demonstrate their art techniques during the fair. If you are inclined to do this, remember to allow space and to bring the proper materials. If you are nervous about painting or sculpting in public, however, don't try to create art at a show.

SALES SUPPLIES

Pack everything you need for a traveling office—pens, receipt book, record book, title/price tags, cash box or register, sacks or paper for wrapping sold art, calculator for computing tax, and address book for names of interested viewers. You'll also need to start with a sufficient amount of cash to make change. Remember to take brochures and business cards if you have them.

Set up your sales table to function in an orderly manner. The sales table can be a hectic place at well-attended shows. If possible, have a helper to transact the actual sales so you are free to interact with the customers. You may want to include enough supplies for two people to transact sales at the same time.

SALES

Be patient and friendly with viewers who stop at your booth. Even if someone makes insensitive comments, continue to be polite. Look at each conversation as an opportunity to educate the public about yourself, your art and art in general. You never know who will want to buy your art, and you also never know what you might learn in some of these interchanges.

Whenever someone expresses a sincere interest in your work, be sure to ask for his name for your mailing list. Even if he doesn't buy anything today, he might purchase something in the future—or know of someone who will.

When you make a sale, be sure to check identification before you accept a check. Confirm the person's address and phone number in case there are any complications with the check. If you decide that you enjoy art fairs and want to continue to participate in them, you can take steps to accept credit cards. Call your credit card company or any credit company for details.

ART FAIR CHECKLIST

Be sure that the show organizers have provided you with a map to the show, your booth location and information about unloading and setting up. Arrive at the show as early as possible so you have plenty of time to get ready before the show opens to the public.

Use this checklist to keep track of the many details you'll need to remember.

- Booth and tools to assemble the booth
- Comfortable chair or chairs
- Tables
- Cooler with food and drinks
- Art (ready to display) and any tools required to hang it
- All sales supplies
- Assistant (hopefully)
- Transportation
- Lodging reservations
- Directions and map to the show

ADVANTAGES AND DISADVANTAGES

There are two things you must keep in mind when deciding to sell your art at fairs. Remember that bad weather can cancel a show and all your work and preparation will be for nothing. Also keep in mind the amount of work and preparation involved. It can be expensive and a lot to organize and manage.

But. . . . I know artists who spend the whole year, when they're not painting or sculpting, traveling from art fair to art fair. They've organized their display so it fits easily into a van. They enjoy seeing the country and meeting artists and spectators who care enough about art to visit the shows.

Some artists show at fairs for fun or extra money, and some support their families on earnings from fairs and festivals. Fairs provide an excellent way to meet the public and sell art.

MAKE FRIENDS

Take time to get to know the artists with booths at the show. They can be a great source of information, and hopefully potential friends. You'll find it wonderful to have art friends to share your experiences with.

It's Your Call

ORGANIZATION WORKSHEET

Every artist's preparation for and needs at an art fair will be different. Use this worksheet to list everything you need to remember, from sunscreen to the art itself. As you pack or complete the task, check off what is done.

Name of Show _____

Date _____

Item or Task	Status	Complete

- Research shows carefully. Check the location, entry fee, booth regulations, whether entry is juried, and the history of the show.
- Organize supplies, art, directions, lodging, and transportation well in advance.
- Plan your booth construction and setup carefully. It's an important sales tool.
- Make friends with fellow artists at the show.
- Be patient and friendly with viewers, and add names to your mailing list.

Sell Your Art at Galleries

Art galleries are public stores intended to sell artwork. They hold exhibitions that are free to the public, but their primary purpose is to find buyers for the art they exhibit. An exhibit in a gallery, even if you don't sell anything, gives public endorsement to your art career.

 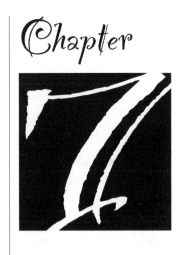

Galleries

ATTEND GALLERY OPENINGS

When you visit a gallery, ask to be included on their mailing list. Then you'll receive invitations to the opening receptions for their exhibits. It's a chance for you to meet artists and art dealers, and to become familiar with the process of gallery exhibits.

The value of art galleries is that they will sell your work. As a professional artist you need sales to pay your bills and to provide legitimacy for your career. There are many more artists producing art than galleries who can exhibit them; the competition among artists for gallery representation is often intense. You can be successful without gallery affiliations, but galleries can be a great help.

VISIT GALLERIES

You should feel comfortable in galleries before you even consider approaching one to exhibit your art. Spend time in them. Pick one day every month or every other week and devote it to visiting galleries. Look in the art listings of your local newspapers and magazines to find the establishments that are available. There might also be a local-gallery magazine in your area. These art guides are usually available free in galleries.

Make a list of galleries and schedule your visits so that you see every one in your area. Make notes for yourself of the type of art shown at each location. Note which galleries and museums show work that is similar to yours. It is very important to observe what type of art the gallery shows.

Whenever you travel, visit the galleries in that area. Immerse yourself in the gallery culture and learn all you can from direct observation and from speaking with the staff.

FINDING THE RIGHT GALLERY FOR YOU

All galleries are different. Some galleries show only prints; some exhibit only original paintings. Some focus on abstract art; others show only representational work. Some specialize in large sculptures; some don't show sculpture at all. Some galleries exhibit local artists; others want artists with a national reputation. The trick is to find the right gallery for you.

Look for galleries that show work that looks like yours. Talk to the salespeople in the gallery. Ask about the focus of the gallery. Ask what kind of work they like to show. Ask them to tell you about their artists. Your work should be compatible with what is shown there and you should feel comfortable in the gallery.

When you are first starting out, I suggest you look for small, neighborhood galleries, new galleries or frame shops that also exhibit art. They will be more receptive to a beginning professional.

KNOW WHO'S WHO IN THE GALLERY

It's important to understand the different roles of gallery personnel. Galleries are comprised of many people, each with their own distinct personality. It's these people who will be your partners in developing your art career. Treat them with respect and consideration, and expect that they will treat you the same.

Here is a list of titles and duties in a typical gallery.

OWNER OR ART DEALER

The person with ultimate control of a gallery is the owner (or owners). This person is also called an art dealer.

GALLERY DIRECTOR

The owner might or might not be the same person as the gallery director. The gallery director decides which artists to exhibit, when to have shows and so on. The gallery director is also responsible for the sales staff. You might find the gallery director on the floor of the gallery or in a separate office.

SALES STAFF

The sales staff works directly with collectors and other visitors to the gallery. You will find them on the floor of the gallery. Their responsibility is, obviously, to sell art. Get to know the sales staff, because they can tell you about the art and artists represented, as well as giving background information on the gallery. When I am showing with a gallery, I make a point of becoming friends with the salespeople because they are the ones who will be selling my art.

SERVICE STAFF

Larger galleries have various assistants, a receptionist, assistant to the director, maintenance crew and so on. Be friendly with everyone. In one way or another they all help sell your art.

STABLE OF ARTISTS

The last members of the gallery personnel are the stable of artists, the artists whose work is represented by the gallery. When I choose a new gallery, I always talk with one of the artists who is already represented by them. I ask how these people are to work with—Are they honest? Are they aggressive about promoting and selling their artists' work? Do they work hard for all their artists?

APPROACHING GALLERIES

Call to make an appointment with the gallery director. Explain that you are an artist looking for gallery representation and ask if they are considering any new work. Some galleries already have all the artists they can handle, so that may be the reason they refuse to see your art.

Sometimes they will ask you to send or drop off slides and a résumé instead of appearing in person. Be prepared to send ten to twenty excellent-quality slides of your best work in an acetate sheet designed to hold slides. Label each individual slide with your name and the title, medium and size of the work. Include your career summary or résumé (which we discussed in chapter four), any brochures or other professional-looking reproductions of your art that you have, and a cover letter that explains that you are interested in acquiring gallery representation. Always include an SASE for return of your slides. Everything should be neat, accurate and professional, much as if you were applying for a job.

After a week or two, phone them to see if they have received your package and to follow up on their response.

The smaller, newer galleries are more likely to see you in person. When you go for your appointment, take your portfolio, a sheet of slides, a career summary and, if you have one, a small, easy-to-carry piece of art. Carry your materials in a neat and orderly presentation. Do not take large pieces of your art: They are awkward to carry and they disrupt the display in the gallery. If the art dealer decides to consider your art for exhibit, she will either ask to visit your studio or invite you to bring in a selection of your art.

IF YOU ARE ACCEPTED

What do you do if the dealer wants to exhibit your art? Before you begin to work with the gallery, ask lots of questions:

- How much art do they want from you?
- When do they need the art?
- Will they be exhibiting your art on a regular basis?
- Will they be using it in shows? Group shows? Solo shows? When?
- How much commission do they take on sales?
- How soon do they pay artists after a sale?
- Will there be any other expenses involved with showing in their gallery, such as for publicity?
- Do they publicize their artists? How?
- Do they want an exclusive agreement (which means you cannot sell your art anywhere else within a given area)?

CONSIGNMENT AGREEMENT

I have found that a simple consignment agreement is generally better than a detailed contract with a gallery. Here is a sample form:

ARTIST'S NAME _____

ADDRESS _____

PHONE NUMBER _____

ARTWORK RECEIVED ON CONSIGNMENT:

Title	Medium	Size	Price
_____	_____	_____	_____
_____	_____	_____	_____
_____	_____	_____	_____
_____	_____	_____	_____
_____	_____	_____	_____
_____	_____	_____	_____
_____	_____	_____	_____
_____	_____	_____	_____
_____	_____	_____	_____

Above artwork is to be sold at listed prices unless specifically agreed by the artist. Gallery will receive _____% of sales price. Artist will be paid within two (2) weeks of sale. Artist or dealer may end agreement with thirty (30) days notice.

Received by: _____ for

_____ _____
 (gallery) (date)

QUESTIONS TO ASK A GALLERY
UPON ACCEPTANCE

When a gallery accepts your work, you should ask questions to clarify all aspects of your agreement. Write down the answers so that you can resolve misunderstandings in the future. Some questions to ask:

How much art do you want me to provide?

When?

Will you exhibit my work on an ongoing basis or only during specific exhibits?

If the art is to be exhibited on an ongoing basis, how much work can I expect to see hanging regularly?

When will you include my art in an exhibit? Will that be a group or solo show?

What kind of promotion will you provide?

Who will pay for it?

Do you want the work framed? If so, who will pay for the framing?

Who will be responsible for transporting the art to and from the gallery?

Do you provide insurance for work in the gallery?

What percentage of the sales price do you keep for your commission?

Do you give discounts to buyers? Does the discount come from the artist's or dealer's percentage?

When do you notify the artist of sales?

How soon do you pay the artist?

Is there anything you expect me to pay for?

How long will you keep the work?

If I want my artwork returned, how much notice do you need?

WHAT YOU CAN EXPECT FROM THE GALLERY

First and foremost, the gallery should display your art. Some galleries with a large space show some work by all of their artists at all times. In a gallery like that, at least one piece of your art should be on exhibit at all times. In addition, if the gallery holds special exhibits, they should schedule your work to be featured in solo or group exhibits on a regular basis, perhaps once a year or once every eighteen months.

Other galleries have only enough space to show featured artists every month. In that type of gallery, your work will be seen only when you are included in an exhibit. When you are accepted into that gallery, they should schedule your work for a future show. Often their schedules are set for a year, or even two years, in advance. Don't be disappointed if your show is not scheduled immediately.

The gallery will probably want photos of your work, and possibly a few extra pieces to keep in racks in case an interested collector wants to see what you do.

When you have an exhibit, the gallery should provide publicity, including invitations, press releases and show listings in newspapers and magazines. Sometimes they will also want to buy ads for your art. They may expect the artist to pay part of this expense. Discuss your financial obligations from the very beginning.

Some galleries offer to provide framing. Don't agree to their framing until you know what it will cost you; it might be cheaper and easier for you to provide your own frames.

When the gallery sells your art, they should notify you and pay you promptly. If they don't, go ahead and ask them why.

WHAT THE GALLERY EXPECTS FROM YOU

The gallery expects that you will give them your best work. They want you to participate in selling your art by providing promotional material such as photos and résumés, and by appearing at openings and being gracious to potential collectors. They also expect loyalty. They do not want you selling your art through competing galleries. They do not want you to sell art directly from your studio to collectors that you meet through the gallery; if the gallery has made the connection, they should get a percentage of the sales price.

It's Your Call

DANGER SIGNALS TO WATCH FOR IN GALLERIES

What kinds of problems can you run into? Sometimes a gallery takes on more artists than they can efficiently represent, and your work ends up stored in a back room. Sometimes management changes and the new director doesn't like your work, and your work ends up in a back room. Sometimes a gallery will have one or two best-selling artists and they will ignore all the rest; your work ends up. . . . These things don't mean it's a bad gallery; it's just not the best gallery for you.

The most serious problems have to do with losing money or art. There are many stories of artists not being paid by dealers or of dealers disappearing with artists' work. Some problems are caused by unscrupulous dealers, but sometimes a gallery innocently falls into financial difficulties.

Here are some clues to help you discover problems before they become disasters:

Your work is exhibited less than other artists on a regular basis.

Your work is advertised less than other artists.

The dealer doesn't return your phone calls.

The dealer is uncomfortable when you appear.

The dealer is much more distracted than usual.

The dealer keeps telling you your art is out on approval.

The dealer delays paying you for a sale.

The staff doesn't know where your art is.

The staff doesn't know who you are.

There is a rapid turnover of staff.

The gallery looks less well maintained than before.

There is a sudden change in exhibit frequency or policy.

There is a sudden change in the type of art being shown.

You hear rumors of other artists unhappy with the gallery.

You hear rumors of the dealer having financial difficulties.

Any one or two of these circumstances might have an innocent explanation, but if you see many or if they keep occurring, consider removing your work from the gallery.

Maintaining a Good Relationship

Any artist who has been involved with galleries for several years will have complaints, sometimes even horror stories, about a gallery. For the last several years I personally have not had any major disasters with dealers. I think it's because I choose them carefully and cultivate the relationships.

You wouldn't think you could just throw a seed in the ground and have it grow without regular care and attention. It's the same with a gallery relationship. After you are accepted into a gallery, you must maintain regular communication with them. Periodically visit the gallery yourself, and send in friends to give you their impressions of how the gallery is doing in general and how they are presenting your work. Continue to ask the gallery what you can be doing to help them sell your work.

If something doesn't please you about your interaction with the gallery, discuss it with the dealer. If it continues to bother you, to the point that you are uncomfortable with the gallery, pull your work out and find a new gallery. There is always another gallery.

The key to getting along with an art dealer is communication. You and the gallery are partners in selling your art. Follow the same guidelines you would follow with any partner. Be reliable about completing anything you promise to do. Be respectful of their time and commitments. Never assume anything that you don't know for sure. Ask questions of your dealer whenever you are unsure. Express any concerns you have before they become problems.

Here are some basic rules to follow:

- Get the terms of your agreement with them in writing. Be very specific, especially about your financial arrangements.
- Keep complete records of the art that you give them on consignment and the work that is sold.
- Visit the gallery regularly to make sure that your work is exhibited. If your work is not on display, ask them why. Be diplomatic but firm about your questions.
- Express interest in sales, but don't hound them. Show a professional interest without being difficult or pesty.
- Give the gallery your best work.
- If you have an exclusive agreement, don't sell work anywhere else in the area.
- Don't sell work out of your studio for lower prices.
- Keep the gallery informed of any developments in your art or your career.
- Communicate about any problems or questions before they become major issues.

THE SAME GOAL

Most galleries work on a consignment basis. You let them hang your work in their gallery, and when a piece sells they pay you the selling price minus their commission. This arrangement works because you have the same goal— selling your art. If your art doesn't sell, that gallery may not be the right one for you.

You and the Museums

The best credentials to put on your résumé are exhibits in museums, either group or solo exhibits. These are also the hardest credentials to get because so many artists are seeking them, so I'll just give you a few pointers here and as you progress in your career you can acquire more information on this particular avenue of exhibition.

First, find out which museums exhibit the work of living artists. You can do this by visiting or calling them. When you find an appropriate museum, call and ask to speak to the curator of contemporary art. Explain that you are an artist and you want to know what the museum's policy is about exhibiting contemporary art.

Many curators of contemporary art have a policy of reviewing art by local artists. They might invite you to come into the museum with your art or to send slides. Follow the same procedure that you would with a gallery. Some museums have a committee that visits local artists' studios. You will find out by calling the museum.

Some museums have juried shows. Ask them to send you a prospectus and to put you on their mailing list. *Art Calendar* is a good source for listings of museum competitions.

Some museums have rental galleries where they hang art by local artists. Members of the community can rent the art on a monthly basis—or buy it. Participating in a rental gallery is often a good stepping-stone to other exhibits with the museum. Phone and ask for specifics.

- The value of art galleries is that they will sell your work. Competition among artists for gallery representation is intense.
- Visit as many art galleries as you can; you should feel comfortable in galleries before you approach them to sell your art.
- Look for galleries that show art similar to your style.
- Small, neighborhood galleries, frame shops and new galleries are the easiest to approach.
- Get agreements in writing if your work is accepted. Keep records of the work you give them on consignment.
- Keep an open line of communication with any gallery that has accepted your work. Visit the gallery often and get to know the staff.

Continue to Sell Your Art

HOW TO GET STARTED SELLING YOUR ART

An art career is an organic creature—it needs constant nourishing. Feed your career by exposing your art to people, especially new viewers. Every time anyone sees your art, hears about your art or reads about your art, it adds to your career.

Chapter

E

Publicity

A great way to nurture your art career is with publicity. There are local and national magazines devoted entirely to art, and most newspapers and magazines include some articles about art. The first step in getting publicity is to read everything you can get your hands on. Read and notice how and where each publication talks about art and artists.

LOCAL PAPERS

Local newspapers often report on art exhibits. They also carry features on interesting artists, art awards and art events such as charity art auctions. Many papers have an art editor who is responsible for deciding which art news will be covered. Phone the art editor at your paper. Ask what kinds of art events they are interested in and how they would like to be informed of them.

Generally the editor will tell you to send a press release. This is a one-page description of the event that gives all the pertinent information in a clear, concise and interesting way. Press releases should always be typed neatly and accurately. Include a name and phone number they can call for additional information. Accompany the press release with one or more black-and-white photos of the art or artist involved. Send press releases about upcoming shows two weeks to a month ahead. This allows the editor time for scheduling.

If you send a press release and your item does not appear in the paper, don't take it personally. Papers have limited space and cannot print everything. Keep submitting press releases.

Whenever you have a public show, you should send press releases to all the local publications. Always send an invitation for your exhibits to local art editors, even for private shows. The more they see and hear your name, the more important they will think you are.

TIPS ON WRITING A PRESS RELEASE

- The first sentence is the most important. It should be interesting enough to make people want to read more.
- The first paragraph should give all the basic facts.
- Write as much information in as few words as possible. Don't ramble. Don't waste the reader's time.
- Keep it simple. Don't use unnecessary big or poetic words.
- Aim it at the particular publication. If it's for a local paper, write why it's of interest to people in that town. If it's for a national magazine, write why it's of national interest.
- Never send a hand-written press release. Always have it typed or printed on a computer.

GO AHEAD AND BRAG

Karen Erickson is the art editor of a small-town newspaper, *The Sentinel-Record* of Hot Springs, Arkansas. Her advice regarding press releases is "You have to really brag on yourself."

She explains, "Your press release should tell what makes you an individual. Tell me what non-artists would like to know. I like to get as much information as I can. That's my job—to fill up my pages. People like to see what's going on locally. I like all different kinds of art and exhibits. Newspapers are advertisement driven; they do like to promote people who advertise, but I always try to be fair and I like to promote things that are not for profit."

WHAT TO INCLUDE IN A PRESS RELEASE

- All the basic information:
 Names (spelled correctly)
 Date of event, including time of day and day of week (e.g., 7:00–9:00 P.M. on Saturday, November 16, 1996)
 Location—address, city, state, directions if it is difficult to find
 Phone number for public event
 Description of the event—what will be happening, what is the purpose, what is unusual about it, who is coming, history of the event
- Information about the artist:
 Where you're from
 How you got started in art
 Education, who you studied under if it's someone people know
 Where you live
 Where you exhibit your art regularly, where people can see your art
 Previous exhibits, awards and other honors
- Information about the art (that the non-artist can understand):
 Description of the subject matter
 Description of the style
 Description of technique
 Good black-and-white photographs of the art and the artist

PRESS RELEASE

To: The Art Editor

The Morning Herald, Smith, Ohio

PRESS RELEASE _____

BOTANICAL GARDEN EXHIBITS WATERCOLORS BY ANN NORTH

Twenty-five watercolor paintings of irises and other garden flowers by local artist Ann North will be displayed March 13–30 at the Highfield Botanical Gardens. A public reception will be held Saturday afternoon, March 13, from 1–4 P.M.

North uses fresh blossoms cut from her own garden as subjects for her paintings. She is a master gardener whose flowers have received awards from the Smith Floral Society and the Ohio State Fair. Her backyard garden produces hundreds of irises each spring.

A native of Smith, she started painting five years ago when she took an art course at Smith Community College. This is her fourth public exhibit.

"I like to paint flowers because they live such a short time. If I paint them, then they last forever," the artist says. "The only problem with painting live flowers is that they wilt; you have to paint really fast."

North's paintings will be available for viewing and sale daily from 10 A.M.–5 P.M. A percentage of all sales will be donated to the botanical gardens. The gardens are located at 1007 Central Avenue. For directions or other information call ■■■-■■■■.

* *

For additional photos or information contact Ann North at ■■■-■■■■.

PRESS RELEASE

LOCAL ARTIST FEATURED IN CHINESE BOOK

Hot Springs artist Carole Katchen was one of only five American artists featured in a new art book published by the government of Taiwan. The book, *Pastel Step by Step*, includes two of Katchen's paintings, a photograph of the artist and a description of her art written in Chinese.

"The Author Aven Chen called me from Taiwan. He had seen one of the art books I wrote and asked if he could include some of my paintings in his new book," says Katchen.

This is the first book about pastel painting ever printed in Taiwan. It is being distributed throughout Taiwan, including more than three hundred libraries in the Taiwanese Republic of China.

Carole Katchen moved to Hot Springs from Los Angeles last September. She exhibits her paintings regularly at Taylor's Comtemporanea Fine Art Gallery in Hot Springs, as well as in galleries in Missouri, New Mexico and Colorado. She has just finished writing her fifteenth book, *How to Get Started Selling Your Art*. It will be published next July by North Light Books, Cincinnati Ohio.

* *

For more information, contact Carole Katchen at ————————————————————— .

ART REVIEWS

Larger newspapers often have an Art Reviewer. This is a writer who attends local exhibits and then writes her opinion of the work. If you want to be considered for a review, send an invitation to the reviewer at the newspaper's address. Include at least one reproduction of the work and a personal letter of invitation. Write well in advance because art reviewers often have busy schedules.

Art reviews depend on the taste and judgment of the reviewer. It's a good idea to study the type of reviews a reviewer writes before you invite her to review your show. You can usually tell the reviewer's biases by reading several reviews.

LOCAL MAGAZINES

Approach local magazines the same way as newspapers, but allow more "lead time." There's usually a lag of three months between layout of the magazine and the time it is printed. Check with each magazine for its schedule.

Phone and ask what kind of information they publish. Think of the telephone as one of your most important art tools. When I phone, I say I am an artist and would like to know how they choose the art subjects to use in their magazine. I explain that I would like to be considered for publication and ask how I can submit material. I have found that if I am polite and honest, I can usually get

answers to all of my questions.

For magazines that are printed in color, include color slides with the press release. As always, use only slides and photographs of professional-quality. Include a self-addressed, stamped envelope for return of your slides.

NATIONAL ART MAGAZINES

National art magazines always look for new art to print and describe. Call and ask how to submit your work. They'll usually ask for a résumé, a description of your working techniques and a sheet of slides. Always include a self-addressed, stamped envelope for return of your artwork.

Before you send your material, look carefully at the magazine. Is the work in it similar to what you do? Your work could be the most brilliant of its kind, but if it's not what the magazine shows, they won't print it.

IF IT'S PUBLICITY— TAKE IT

Generally, any kind of publicity is good publicity. Photos on the society page, paragraphs in the church bulletin, letters to the editor, reproductions in the alumni newsletter—it all helps your career. Remember, your career thrives on people hearing your name and seeing your art. Any time you have an opportunity to show your art, take it.

Paid Advertising

Should you invest in advertising? It depends on your budget. If you have little money, there are probably better ways to spend it than paid advertising. On the other hand, many artists set aside funds every month for advertising.

Ads in magazines, especially national art magazines, can be a wonderful way of getting your art seen by a wide audience. However, those ads are quite expensive. Unless you can afford a nice-size ad, preferably ¼ page or larger, with a big reproduction, I don't think they have much impact. Also, one ad alone does not usually do much good. The most effective use of ads is with regular appearance over a period of time rather than a one-time ad.

ONE ARTIST'S AD CAMPAIGN

Well-known painter Urania Christy Tarbet advertises regularly in magazines and says, "I think it has made a great deal of difference to my career, especially in name recognition. Even in other states I will walk into a gallery and they will know my name because of the ads."

At the beginning of every year she plans her advertising program for the coming year. She sits down with all the art magazines she can find. She picks the ones that seem most suitable for her art and she writes or calls for a "rate card." Usually the magazine will send a complete packet, with prices for ads as well as detailed information about circulation and demographics (who buys the magazine).

She says, "I always buy at least three ads in a row. You can't think, 'I'm going to advertise once and everyone will beat a path to my door.' It takes a while to establish name recognition. I have found it's just as effective to take out a small ad (no smaller than ¼ page, though) as a larger ad. Make the image large and the print small."

PLAN A CAMPAIGN

If you want to advertise in magazines, I suggest you plan a year-long campaign like Urania does, keeping in mind that repetition is what gives advertising its power. If you are affiliated with a gallery, ask if they would like to share the cost of the ads with you. Many galleries will be pleased to do so. It gives the gallery more exposure and establishes them as the representative of your art. Your art appears more established when it is listed with a gallery.

There are times when a single ad is worthwhile. If you are having a major public exhibit, ads in newspapers and magazines at the time of the show can reinforce the impact of your invitations. Also, if you are featured in an article in a magazine, running an ad near the article will inform interested readers of where they can find your art.

It's Your Call

Be Creative to Gain Advertising

There is a story I heard about Fritz Scholder, who has become one of the foremost artists in America. Early in his career no one wanted to handle his paintings of the American West. What was popular then were romantic images of cowboys and Indians galloping across the plains. Scholder painted distorted, wildly colored Indians in the style of Expressionist Francis Bacon.

After years of obscurity, he contracted with a large national art magazine for a year of full-page, full-color ads of his art. It was a gamble for the artist, who didn't have anywhere near the $10,000 he had agreed to pay. After a few months he still had no results and no money to pay for the ads, but the magazine's contract said that if they discontinued the ads before the full year, he would not be held responsible for payment.

So the ads continued, and by the end of the year galleries and collectors from around the country were contacting the artist. They were convinced that anyone who got so much attention in a national magazine must be important. Today his art is proudly hung in major galleries and museums around the world.

GOOD PR HELPS WITH GALLERIES

"If an artist has professional slides, I know they care enough to invest in their own career," says Carolyn Taylor of Taylor's Contemporanea Fine Art Gallery in Hot Springs, Arkansas.

"You have to have good slides. I look at the slides before I look at anything else," she says. "I hold them up to the light and that first glance determines if I go on to the projector.

"Then I check the artist's background. I want to get a sense of the artist and see if he's really serious. I want to see a consistent effort in his career.

"An Artist's Statement is important. This is not just a bunch of words on paper. It should say what the artist is really thinking.

"Part of my obligation as a gallery owner is to be courteous and generous to young artists, but another part is to introduce them to the proper way of presenting themselves. If you're an artist and you're planning to sell your art so you can have money to buy food, you have to act like a professional. This is the job. This is not degrading your art— this is just the reality of it."

Prints and Posters

One way to reach a wider audience is with prints or posters of your art. However, the success of prints depends on distribution—getting them out to potential buyers. I advise beginning artists to not produce prints unless they have a well-thought-out marketing plan. It takes a tremendous amount of time and energy either to get your prints placed in a large number of shops and galleries or to set up a successful mail-order system. Prints are expensive to produce and, if you are selling them yourself, they can be as hard to sell as original pieces of art which bring higher prices.

There are two ways to make prints work for you. One is to find an established print publisher who likes your art and is willing to buy it for production by his company. The other is to produce a poster in conjunction with an exhibit or charity event. The sponsor of the exhibit or event should pay a substantial amount of the printing cost and should help provide distribution.

A PRINT MARKETING CHECKLIST

Sue Viders, Art Marketing Director for Color Q, Inc. and an independent art marketing consultant, has developed the following checklist for marketing prints.

- Plan your print with a specific purpose and audience in mind.
- Test market your original artwork at fairs, festivals and shows.
- Decide on your distribution system (e.g., direct mail, fairs, galleries and shows).
- Develop a price list and an order form. Consider pre-selling your print with a pre-publication offer at a reduced price.
- When ordering your prints, also order promotional literature (e.g., intro sheets, postcards and greeting cards) to be used as handouts, mailers, invitations and thank you notes.
- Obtain mailing lists and conduct mailings of invitations, promotional pieces and so on.
- *Always* follow up with additional mailings and personal phone calls. *Persistence* is how most sales are made.
- Send thank you notes to buyers. Add these names to your customer list.

LIMITED EDITIONS

Limit the number of reproductions made from the original art and you can offer limited-edition prints. Include a certificate of authenticity with each print.

It's Your Call

Maintaining a Balance

Success Story

With all of the time and energy you are putting into meeting new people, hanging art, selling art, getting publicity and keeping track of business, you might lose sight of your art. That's one of the biggest dangers of becoming a professional. I know there are times when I am away from the studio too long. I start to get irritable and wonder why I ever decided to become an artist in the first place. The solution is easy: Get back into the studio and paint.

Remember that creating the art is what feeds your soul. Whether it's the joy of mixing new colors, the challenge of achieving a perfect watercolor wash or the breathtaking risk of carving a new piece of alabaster, the process of creating art is the source of your joy.

KEEPING THE BOOKS

With paintings hanging all over town, slides flying all over the country and new contacts made every day, it's more important than ever to keep track of everything. Keep complete records—an inventory of your art, the mailing list, and records of contacts and follow-up. If you are not an organized person, get someone to help you set up a simple system for keeping track of it all. Develop a file system or put it all on computer, but keep records of everything and keep it all as current as possible. Start at the beginning of your career, before it gets overwhelming.

TAKE CHANCES

No matter how good your art is now, it can always get better. That excitement of gaining greater perception, learning new skills and surpassing old limitations will give you greater energy for the business side of your career.

There are artists who find an image or a technique that sells well and they keep producing exactly the same art for years because they are afraid of losing their following. This is a terrible trap. You end up copying yourself. All of the freshness and spontaneity disappear. Eventually you will lose your following anyway, because the art lacks vitality.

Don't be afraid to take chances. Don't be afraid to grow. You may lose some collectors, but you will always find more. When you make the commitment to being a successful professional artist, the only thing that can stop you is you deciding to stop.

Nurture your art career with publicity. Gain publicity through:

LOCAL NEWSPAPERS AND MAGAZINES
- Send press releases whenever you have a public show.

NATIONAL ART MAGAZINES
- Call and ask how to submit your work.

PAID ADVERTISING
- National ads are expensive, but are effective if your ad is at least ¼ page and appears over a period of time rather than just once. Plan an advertising campaign.

PRINTS AND POSTERS
- Develop a marketing plan if you plan to use prints and posters.
- Find an established print publisher.
- Produce a poster in conjunction with an exhibit or charity event.

MAINTAIN A BALANCE
- Don't use all your energy to sell art. You must create in order to have something to sell.
- Be diligent about keeping complete records.
- Take chances.

Chapter Summary

Do What You Love

HOW TO GET STARTED SELLING YOUR ART

Being an artist is not a place that you reach; it is an everyday process of creating art and presenting that art to the world. Enjoy the process and congratulate yourself on having the wisdom and the courage to spend your life doing what you love.

Do What You Love

There is something romantic about the very notion of being an artist. Art has such a wonderful tradition. Leonardo da Vinci, Reubens, Renoir and Michelangelo: The names alone are romantic. Say the word *artist* and you conjure up centuries of masters in lofty ateliers and novices in cold garrets, purple fingertips pushing through the holes of worn woolen gloves. You see witty companions sharing a bottle of wine, wealthy burghers posing for portraits, long taffeta gowns at a salon exhibition and a lone easel on a windswept English cliff.

Is it really all that romantic? I've been a professional artist for more than thirty years. Has my life been filled with romance? The truth? Yes, absolutely.

OK, there have also been moments of frustration, fear, exhaustion, isolation, poverty and jealousy. Still, even in the hardest times I knew I was following the line of other artists who had also endured and overcome through their creation—Carravagio, Tiepolo, Millet, Cassatt, Sargent and Bonheur. Every day they continue to share with me the gift of their art, just as I will share mine even after I am dead. This is the romance of being an artist.

Throughout the ages artists have been young and old, men and women, rich and poor, talented and mediocre, French, Russian, African, Chinese and Persian. What is the one quality they all shared?

Commitment. The commitment to be an artist.

That is what it takes. That is *all* that it takes. Anyone who makes the commitment to being an artist can be an art-

ist. Let me repeat that. Anyone who makes the commitment to being an artist can be an artist.

That's the good news and the bad news. It is good news because it means that anyone—no matter who you are, no matter where you are in your life—anyone can be a professional artist. You simply declare, I am an artist, and start to create art.

The bad news is that making such a major commitment requires courage, perseverance and faith. Committing yourself to being a professional artist means that you are willing to do *whatever it takes* to reach your goal. No matter what anyone else thinks of you, no matter what anyone else says about you, you have to be willing to hold fast to your goal. You must believe you will reach your goal, no matter what.

What is your goal as an artist? Do you simply want to sell a few paintings? Do you want your art to hang in a gallery? Do you want your art accepted in a museum collection?

I promise you can achieve any of these goals if you are willing to make the commitment and do the work. You do not have to be the right age, the right sex, or the right social class. You just have to be willing to do the work.

In this book I have attempted to give you information and techniques that will help you on your own journey as an artist. The first step is simply saying that you are an artist. After that, all there is to do is keep taking one step after another. Be patient with yourself. Be kind with yourself. And refuse to stop.

Index

HOW TO GET STARTED SELLING YOUR ART

More Great Books for Creating Beautiful Art